Fritz Scholder
Lithographs

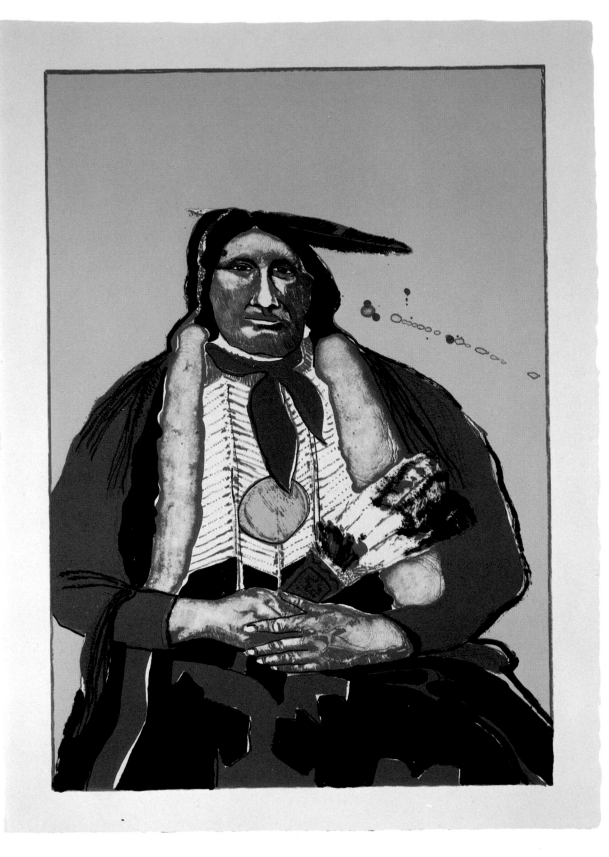

INDIAN WITH FEATHER FAN (First State)

February 1975 [75-609], five color
30 × 22 (76.2 × 55.9), white Arches
Edition: 150 plus BAT, TP, 4CTP, 10PgP, 15AP, 2T
Printed by Ben Q. Adams

Fritz Scholder Lithographs

Text by Clinton Adams

New York Graphic Society

Boston

Library of Congress Cataloging in Publication Data

Adams, Clinton, 1918–
 Fritz Scholder: Lithographs.

 Bibliography: p.
 1. Scholder, Fritz, 1937– I. Scholder,
Fritz, 1937–
NE2312.S36A65 769'.92'4 75–9106
ISBN 0-8212-0689-3
ISBN 0-8212-0690-7 deluxe

Photo credits: Colin C. McRae, page 16; Tamarind Institute, pages 22–23;
David Van Riper, pages 8, 28.

First edition

Designed by Jack O'Grady

New York Graphic Society books are published by Little, Brown and Company.
Published simultaneously in Canada by Little, Brown and Company (Canada) Limited.

Printed in the United States of America.

The lithographs have become an important part of the work.
As a painter-printmaker and fetish maker,
I revel at being able to produce statements in various forms.
In today's world, love, art and magic are greatly needed.

Fritz Scholder

Scottsdale, Arizona, July 21, 1975

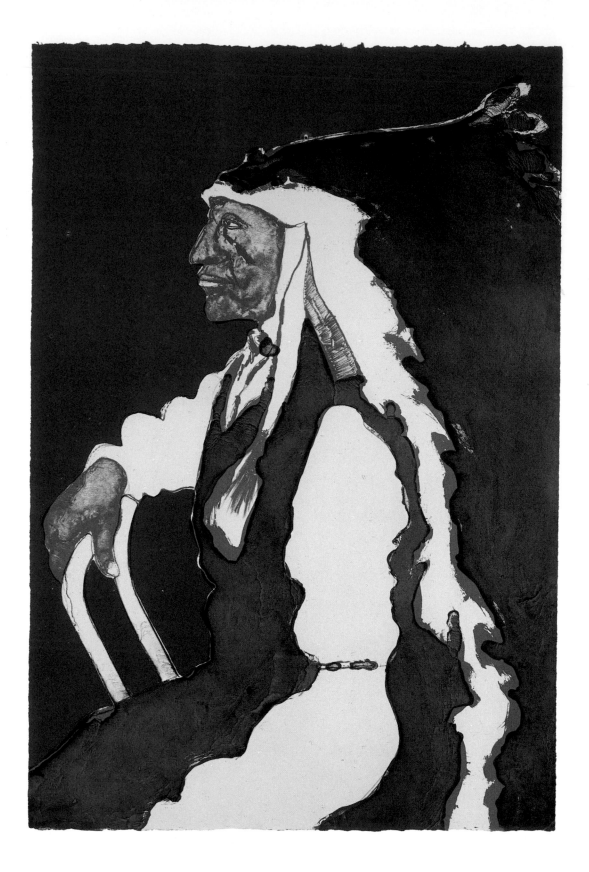

PATRIOTIC INDIAN (First State)

February 1975 [75-610], two color
22 × 15 (55.9 × 38.1), buff Arches
Edition: 50 plus BAT, 3TP, 2CTP, 5AP, 2T
Printed by Stephen Britko

Contents

Fritz Scholder and the Lithographs

I

North and east of Albuquerque, past the granite wall of the Sandia range, the land rolls higher, dotted with piñon and juniper, to the volcanic mesa of La Bajada. From the top of the mesa the expanse of sky, land, and mountains overwhelms the eye. At the base of the mesa lies the usually dry stream bed of Galisteo Creek, a small tributary of the Rio Grande. Eastward some twenty miles is the village of Galisteo, built on the site of an ancient Indian pueblo, mentioned as early as 1581 by the Spanish explorers of New Mexico. The village clusters by the creek, beside a road leading from the Estancia Valley to Santa Fe, more than twenty miles farther north.

Fritz Scholder's home in Galisteo perfectly symbolizes the facets of his life. Remote and solitary, completely walled and enclosed, it reflects in its traditional portico and adobe construction the heritage, the ambience, and the mystique of New Mexico. The house and its furnishings are, in contrast, thoroughly contemporary, rich and exciting in color and texture. The studio is large and simple. "Stark," Scholder calls it. A place to work.

Scholder travels widely. The winter months are now usually spent in a second home in Scottsdale. "My first twenty years in the Dakotas gave me enough cold weather," Scholder explains. "I have always wanted a place in the desert where I could be warm the year around." Whether in New Mexico or Arizona, Scholder remains always a southwesterner, rooted in the land. He finds it a healthy place to work, healthy not only in a physical sense, but also aesthetically.

Santa Fe calls itself The City Different. Set closely against the lower slopes of the Sangre de Cristo mountains, the city backs up to the forest. About one-sixth the size of Albuquerque, the metropolis down the road, Santa Fe immediately impresses the visitor as a city unlike any other. Its tricultural heritage is apparent not only in its typical architectural style, which combines Indian, Spanish, and neoclassic elements, but also in the faces of the people. The oldest European community west of the Mississippi River, founded in 1610 by Don Pedro de Peralta, Santa Fe is today a curious blend of authentic history, tacky curio shops, fine restaurants, plastic suburban housing, art galleries, museums and opera, state government offices, mansions, and slums.

Fritz Scholder first came to Santa Fe in 1964 to teach advanced painting and art history at the new Institute of American Indian Arts, a school established by the United States Department of the Interior "with the objective of making Indian art students more secure as individuals." His background at that time was far from the stereotype of an Indian artist held consciously or unconsciously by most Americans, particularly in New Mexico.

9

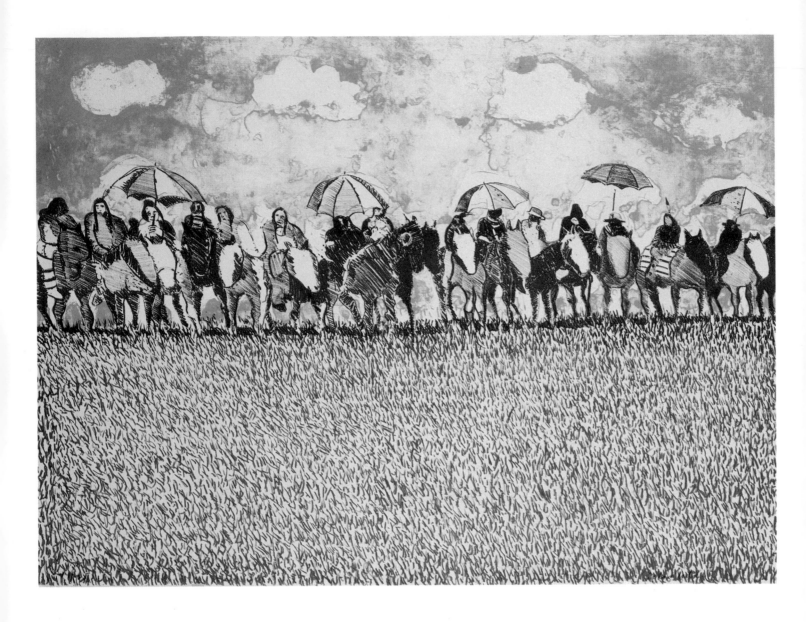

INDIANS WITH UMBRELLAS (Indians Forever Suite)
March 1971 [71-152], four color
22 × 30 (55.9 × 76.2), buff Arches
Edition: 75 plus BAT, 4TP, 6CTP, 6AP, 2T, 5R, 2PP, CP
10 Printed by John Butke

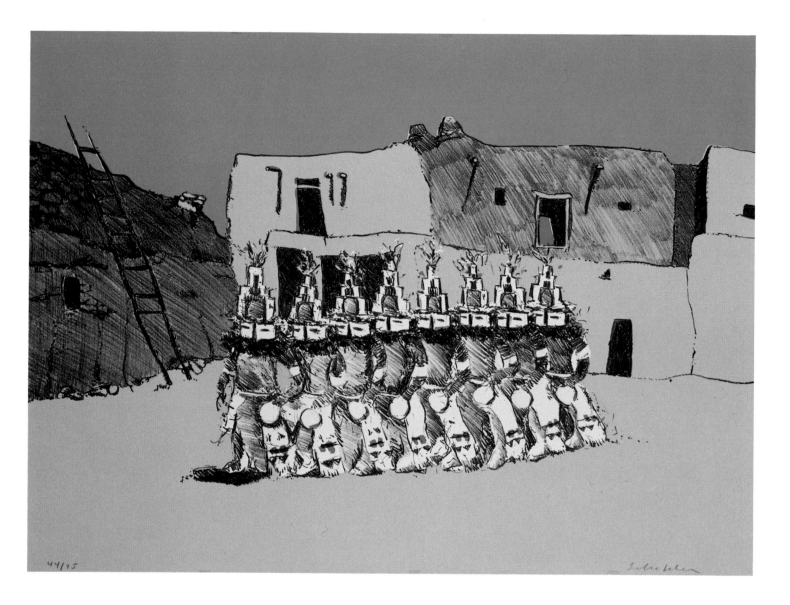

44/75 Scholder

KACHINA DANCERS (Indians Forever Suite)

January 1971 [71-105], three color
22 × 30 (55.9 × 76.2), buff Arches
Edition: 75 plus BAT, 7TP, 4CTP, 6AP, 2T, 5R, 2PP, CP
Printed by Julio Juristo

Scholder is a contemporary American artist who is by birth one-quarter Indian. Upon his arrival in Santa Fe he was far more conversant with the central tendencies of American vanguard painting than were most of the artists on Canyon Road. He rejected totally the "western" paintings in the windows of the tourist galleries: the acres of aspen trees, of cowboys and Noble Savages.

His aim from the beginning as a teacher at the institute was to introduce his young Indian students to art as it really was, to share with them the dedication and commitment that he brought to his own painting.

Scholder had himself been exceptionally fortunate in his art education. It is all too seldom in any American high school, whether rural or metropolitan, that students have an opportunity to study with a professional artist. It was thus a stroke of luck when in 1950 Scholder's family moved to Pierre, South Dakota. In Pierre he had as a teacher the Indian artist Oscar Howe, a painter who had been in Paris during World War II and who while there had been exposed to contemporary art. "He told us about his reactions to it," Scholder recalls. "I made cubistic paintings in his fashion for a while and he instilled in me a realization that art could be exciting and serious, that it was much more than painting pretty pictures." In good part because of Howe's influence, Scholder while still in his early teens made the decision to try to become a serious painter.

During the summer before his senior year in high school, he went to a summer art camp run by the University of Kansas. His freshman year in college was spent at Wisconsin State University in Superior, where he was trained in the Bauhaus disciplines that were central to the curriculum in most schools and colleges in the 1950s. Then luck came again, and this time crucially. His family moved to California.

Wayne Thiebaud, who was then teaching at Sacramento City College, is both one of the country's leading artists and, less widely known, one of its leading teachers. Scholder speaks of his study with Thiebaud as his greatest good fortune. "He not only taught me a lot about painting, but about art history as well." This was in 1957 and 1958. The currents of abstract expressionism ran strong in California, and the idiom of these artists was a natural one for Scholder. Thiebaud, whose attitudes toward subject matter also left a residue in the younger artist's thought, was instrumental in arranging Scholder's first one-man show in 1958, while Scholder was still an undergraduate.

After receiving his bachelor's degree in 1960, Scholder stayed on in Sacramento for another year, working part-time as a substitute teacher in the public schools. In 1961 he was awarded a full scholarship to participate in the

12

Southwestern Indian Art Project at the University of Arizona, an important new program supported by the Rockefeller Foundation. This project for Indian artists was designed "to expose them to past and present art and to explore new teaching methods in art. Students were bombarded with all kinds of films, books, and music. The students made both sophisticated and primitive types of Indian paintings." It was the first time that Scholder had been involved as an artist in a situation consciously *Indian.*

His own work at that time had no connection with "traditional" Indian painting. As an artist he felt a far closer affinity with the paintings of Thiebaud, Diebenkorn, and Oliveira than with anything Indian. Even so, there can be no question that the Rockefeller Project represented a critical turning point in his life and work. With the aid of a John Hay Whitney Opportunity Fellowship, he stayed on in Tucson to complete a Master of Fine Arts degree at the University of Arizona in 1964, before moving on to the institute in Santa Fe.

His first New Mexico paintings were a "stripe" series distantly reminiscent of Diebenkorn's early Albuquerque series. Scholder's paintings were rich and glowing in color, painterly in execution, and somehow evocative of landscape, despite their total abstraction.

But at the new school he found himself once again immersed in things Indian. His students were Indian. He began to attend the ceremonial dances at the pueblos near Santa Fe and to collect Indian art. His awareness of his own Indian heritage was thus intensified.

Although upon his arrival in Santa Fe he had vowed that he would not paint the Indian, he found himself having second thoughts. "I had at first to deny the Indian subject because it had become such a tremendous visual cliché. Not only a visual cliché but a psychological cliché. Everyone in this country had his own idea — his preconceived idea — about the Indian." The question that later came to Scholder's mind was whether it might be possible to paint the Indian in some new way. Could he break through the cliché established by non-Indian artists, the romantic vision of the Indian? Could he *transcend* the stereotype?

So one winter night in 1967 he painted his first Indian. "My work immediately startled many people because I, part-Indian, treated the Indian differently, not as the 'noble savage' endlessly portrayed by White painters, and also because my technique was non-Indian. I felt it to be a compliment when I was told that I had destroyed the traditional style of Indian art, for I was doing what I thought had to be done."

More than three hundred paintings of Indians were to follow that first one. Indians of all ages, Indians in all guises, Indians never seen before.

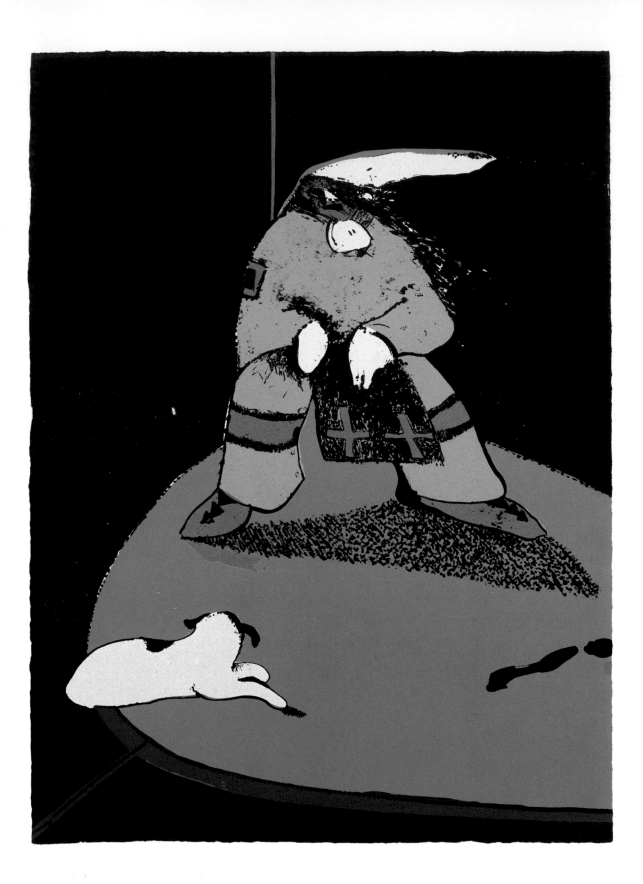

INDIAN AT THE CIRCUS (Indians Forever Suite)

December 1970 [70-185], five color
30 × 22 (76.2 × 55.9), German etching paper
Edition: 75 plus BAT, 4TP, CTP, 6AP, 2T, 5R, 2PP, CP
14 Printed by Tracy White and Wayne Kimball

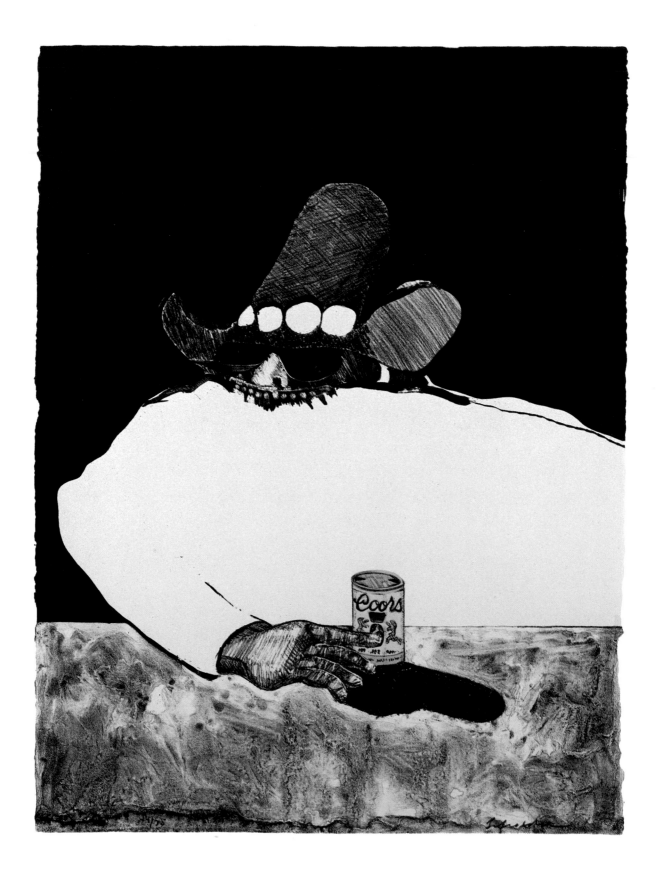

INDIAN AT THE BAR (Indians Forever Suite)

February 1971 [71-117], four color
30 × 22 (76.2 × 55.9), buff Arches
Edition: 75 plus BAT, 5TP, 6AP, 2T, 5R, 2PP, CP
Printed by Wayne Simpkins

Scholder left the institute in 1969, but he did not leave the Indian. That spring, after a winter trip to Europe and North Africa, he bought a house on Canyon Road and began to paint full time.

II

Much of twentieth-century art is in one sense or another expressionist. Beginning with Van Gogh and Gauguin, it has generally been true that, in Matisse's phrase, a painting has been a moment of the artist, not a moment of nature. This is the central concept of expressionist art: an artist gives form to a personal view through his use of the medium. Van Gogh's passionate brushstrokes record the fervid intensity of his assault upon the canvas; Gauguin's exotic color and arabesque of line communicate his emotive responses to the subject matter before him.

A critical moment came when Matisse in 1905, in a portrait of his wife, audaciously painted a line of brilliant green from forehead to chin, a color that shocked the vision of the viewer into a new manner of perception while at the same time serving to structure the formal relationships between the face and the background. Color, in the paintings of Matisse, the Fauves, and their German contemporaries, became a principal means of expression. Coloristic "distortions," visible brushstrokes, deliberately crude or "unfinished" passages were effective means whereby the avant-garde painters of those years might seek to disrupt the formal and technical conventions of academic painting. Matisse in his *Blue Nude* of 1907 sought not only to break through these formal conventions but, significantly, to give new life to a subject, the female nude, which in the hands of Bouguereau and his confreres had become a total stereotype.

Scholder's need to transcend the stereotype of the Indian as subject matter was directly comparable, and his original vow not to paint the Indian had its earlier parallel in the call of the Futurist painters (in their manifesto of 1910) for "the total suppression of the nude in painting" for a period of ten years. "Nothing is *immoral* in our eyes," they wrote; "it is the monotony of the nude against which we fight."

Scholder's fight against a similar monotony in depiction of the Indian was made in terms that echo Matisse's nude. From the beginning of the series in 1967, Scholder made use of expressionist brushwork and non-naturalistic color as devices to get the Indians "away from what they were," hence the green,

17

blue, or violet faces of his Indians and the startling color contrasts between the figures and their environment.

While in London during the winter of 1969, Scholder was immensely impressed by a group of Francis Bacon paintings then on exhibition at the Tate Gallery. He found himself in full accord with the premise of Bacon's work, that "a picture should be a re-creation of an event rather than an illustration of an object." The terror and cruelty of Bacon's images deeply affected him; he felt an affinity with Bacon's visual means. New weapons were thus added to Scholder's arsenal when in the fall he returned to Santa Fe and again laid siege to Indian stereotypes.

Scholder acknowledges Bacon's influence in many of his paintings and lithographs of 1969 to 1971. "For me," he says, "Bacon is the most important living painter. Strong images and color: that is what painting is all about."

But Bacon's influence was soon assimilated. In an essay on Scholder's work written in 1973, Joshua C. Taylor pointed out that although "certainly Scholder admires the paintings of Bacon . . . there is nothing in his work that repeats Bacon's claustrophobic hysteria and anguish over the conflict of soul and flesh. No matter the seeming hopelessness of their condition, Scholder's people have the vitality to prevail."

There is, above all, Scholder's insistent wit, his ever-present sense of humor. He perceives the unexpected and the anachronistic in the life of the twentieth-century Indian, the tension that so often exists between the traditional way of life and contemporary American society. He has a sense of both the tragic and absurd aspects of this tension. Even when depicting the Indian as "a monster" he does so with the compassion due a profoundly human being.

"Many misinterpret my painting of an Indian in a buffalo headdress and full buffalo dance regalia because he is shown holding an ice cream cone. I actually saw a buffalo dancer eating an ice cream cone between performances at the big spring dance at Santo Domingo Pueblo. I wanted to depict the strange paradox of a deeply religious animal dancer, whose dancing tradition goes back hundreds of years, eating ice cream bought at a White man's food concession in Pueblo grounds. It could only happen in the twentieth century."

Such subjects as this have led some critics to align Scholder with Pop Art. The connection is tenuous at best. Although Scholder has clearly been aware of Pop attitudes and tendencies for some years, he does not fully share the cool, hip posture of the true Pop artist. The essential seriousness of his concern for the Indian prevents his work from becoming merely "witty, sexy, gimmicky and glamorous," to use but a few of the terms from Richard Hamilton's definitive definition of Pop.

The resemblance between Scholder's work and Pop Art is most clearly seen in their common involvement with clichés. The difference lies in the way they use them. Warhol in his silk-screen paintings of Marilyn and Liz intends the cliché to remain a cliché; he intensifies the stereotype through constant, machinelike repetition. Scholder begins with a cliché but seeks to lead the viewer beyond it.

"Pop Art is a bad term — at least for many people. I stay away from labels because they do more harm than good." As Scholder sees it, his paintings of Indians with ice cream cones, like Thiebaud's paintings of cakes and pies, are simply artifacts of contemporary American life.

"If a Pop artist is one who is challenging clichés, then, in a way, I must be one, because the American Indian has become the biggest of clichés." Ultimately, however, he feels he must reject the term. "A California newspaper recently saw my work as some kind of a protest — a political statement. I deny it. I am interested in making a strong painting or a strong lithograph, first of all, for aesthetic reasons."

Nor is one quick label better than another. "I began painting Indians long before it was fashionable to do so, so of course everyone started to call me an Indian Artist — which I have never called myself. People can't seem to understand. To tell the truth, I don't know what Indian Art is."

III

It was in the summer of 1970 that Tamarind moved from Los Angeles to Albuquerque. Already well known as America's foremost lithographic workshop, Tamarind had by then been operating for ten years on a side street in Hollywood (Tamarind Avenue, hence the name). During the late spring, the workshop was disassembled, and the stones, presses, and other equipment were shipped to New Mexico. A warehouse building adjacent to the campus was purchased by the University of New Mexico and remodeled to meet Tamarind's needs. During the summer months the workshop was forced by construction delays to operate in temporary quarters, so that it was not until fall that Tamarind Institute could open its doors on Cornell Avenue. The shop was designed for a total of six presses; three were on hand when it opened. Of the six printers, three had come from Los Angeles and three had joined the program in New Mexico.

While Tamarind had been in California, its substantial grant from the Ford Foundation made it possible to offer fellowships to artists. All work was by

invitation, and no charge was made for either materials or services. In New Mexico it was planned that the Ford Foundation's support would gradually be withdrawn and that a large part of the printing done for artists would be either on a contractual basis or as a publishing venture.

Despite its small population, New Mexico is a state which has historically attracted a disproportionate number of the nation's leading artists. It was with the thought of bringing these artists to the workshop that, as Tamarind's director, I first spoke with Robert A. Ewing, then Curator-in-Charge of Fine Arts at the Museum of New Mexico in Santa Fe. It was my hope that the museum and Tamarind might cooperate in publication of lithographs by New Mexico artists. Scholder's name was the first to be mentioned.

Scholder's only earlier experience with lithography had been while he was a student at Sacramento State College. "It was disastrous," he recalls. "I took a class where we worked in lithography; I did the actual work, or was shown how to do it. Three prints were pulled in editions, a grand total of perhaps five impressions. The first was of a nude woman standing in a landscape, then a face of an owl, and a cat — but I didn't like the medium. It was very laborious and terribly technical."

Even so, when Ewing spoke to him of our conversation, Scholder's interest was immediate. He knew of Tamarind, and despite his first poor experience with lithography, he wanted to explore that medium.

Although, as it turned out, the museum was unable to participate, arrangements were soon completed for the beginning of Scholder's work. The project he had in mind was a suite of lithographs, a series of works related in theme and spirit, and presented as a unit in a folio. The subject, of course, would be the Indian. Indians Forever, it would eventually be called.

After discussions among Scholder, his publishers, and the Tamarind staff, a tentative contract was signed. Although as originally planned the suite would include eight images, it was impossible to anticipate how many colors might be needed in each of them. Scholder chose a generous format, twenty-two by thirty inches. That size would make it possible to use full sheets of fine imported rag papers without tearing their natural deckle edges. It was a size within which Scholder was sure he would feel comfortable.

In the workshop, preparations were made for Scholder's arrival. One by one, the heavy slabs of gray Bavarian limestone upon which he would draw were taken to the graining sink and ground by hand with fine carborundum. It was work such as this that Scholder had in mind when he called lithography "laborious." Each of the stones must have a perfect surface, free of flaws and

scratches — and it takes long, hard hours to achieve this. As a student he had had to do it for himself; at Tamarind the apprentice-printers did it for him.

Soon all was ready for Scholder to start work. He clearly remembers his first day at Tamarind. It was December 8, 1970. The printers were waiting when he arrived at the workshop early in the morning, nervous and apprehensive. The white walls of the pressrooms, the absence of color, the high illumination, and, above all, the atmosphere of discipline were intimidating. He was in awe of Tamarind's reputation. He felt suddenly strange and alone. He missed the familiar surroundings of his studio. There he was used to painting to music; at Tamarind, in contrast, the sounds were those of the work being done: the loud whine of the hydraulic lift-truck as one of the massive stones was moved, the motors of the press-beds, the rattle of the tympan sheets, the conversation of the printers and curators.

"It was all very different, just the physical thing of working there. I also felt strange because I really didn't have any technical knowledge of lithography. What little I had learned in college was long gone."

The first of the stones was taken to the semiprivate studio area in which Scholder would work. Its protective cover was removed. The printers put out the drawing materials: tusche and lithographic crayons. Scholder asked a few questions, the printers made a few suggestions, then he simply went to work. The drawing for *Waiting Indian* was completed that first morning.

When an artist works on a series of lithographs, he collaborates not with one printer but with several. In that way work can go ahead simultaneously at several presses. The time required for processing the stone, proofing it at the press, and later printing the edition is far greater than the time spent by the artist in drawing it. Thus while one printer moves his project forward, the artist is free to work on another.

Julio Juristo was Scholder's printer for *Waiting Indian*. Together, he and Scholder took the processed stone to the press. The image now lay under a film of gum arabic, the tusche and crayon replaced by printing ink. Although Scholder had drawn the image rapidly and with conviction, he could not be sure how it would look when it was printed. He knew that it would be reversed from left to right. The blacks in his drawing would be seen against the brilliant white of paper rather than against the middle-gray of the stone; all contrasts would thus be intensified. He had tried to visualize these changes, but couldn't be sure he had done so accurately. Now all he could do was wait while Juristo went through the necessary technical steps that must precede the pulling of the first rough proof.

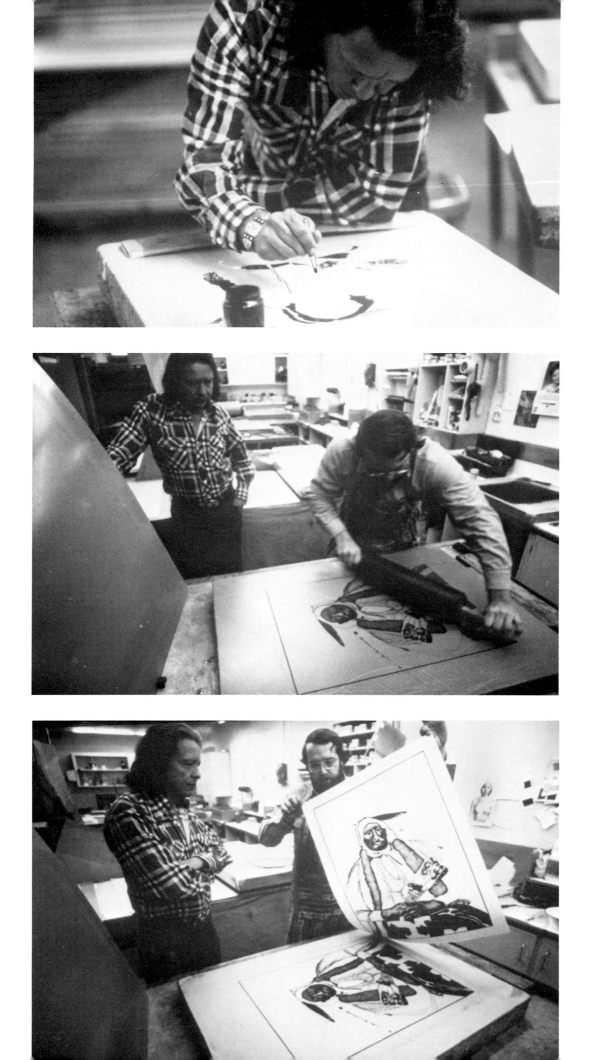

It was with good reason that lithography's inventor, Aloys Senefelder, at first wished to call it "chemical printing." It is a chemical process, not a physical one. Unlike the other print media, the stone when printed is essentially flat. The function of the etch the printer uses (a mixture of gum arabic and acid) is not to erode the surface, but rather to stabilize it chemically, separating the grease-receptive areas created by the artist's drawing from those that were left untouched.

Scholder stood beside the press, watching as the gum was sponged from the stone. The printer's assistant (or "sponger") kept the surface evenly damp, as with his leather roller Juristo applied the greasy ink.

"It was exciting. Exciting, yet very traumatic. I remember being disappointed by the first proof on common paper. It hadn't come up fully so it looked very shallow. But as Juristo worked on and as other proofs were taken I could see it gradually getting richer, and closer to what I had in mind. That first print was like giving birth. I didn't really know what was going to happen."

Waiting Indian emerged as a strong but simple statement, a monumental standing figure, a single black mass against an all-but-untouched white ground. Although drawn primarily with solid black tusche and crayon, Scholder had used diluted tusche washes in a few small areas. Pleased and intrigued by their visual qualities, he quickly decided to use them further.

The second stone was drawn that very afternoon. Already Scholder's initial nervousness was gone. As a painter used to working in solitude (as all painters do), he still found it strange to be, as it were, on center stage, expected to perform, to bring off miracles. But the successful first proofing session and Juristo's helpful confidence were making him feel at home.

In the second drawing Scholder placed the standing figure in profile. The washes expanded to fill the entire area of the Indian's robe, rich and complex in their shifting tonalities. The face and hair were delineated with sharp staccato lines; a single feather projected horizontally and dramatically to the drawing's edge. The background was painted a solid black.

The washes used in *Indian with Feather* were the beginning of Scholder's subsequent exploration of what is at once one of the most beautiful and most challenging of lithographic processes. Washes permit the artist no second thoughts, no tampering or hesitation; they demand that he be both sure and direct. In *Indian with Feather,* Scholder's spontaneous certainty is immediately apparent. It is a truly impressive lithograph, a quite amazing achievement to be but the artist's second work in an unfamiliar medium. Scholder to this day regards it as the most successful of the eight lithographs included in Indians Forever.

The suite as planned was to include both black-and-white prints and lithographs in color. On the morning of his third day at Tamarind, Scholder began an ambitious five-color lithograph, *Indian at the Circus.*

The making of a color lithograph requires a kind of analytic thinking that is quite foreign to the way a painter usually works. Not only must he cope with the mirror-reversal of the image, as in black and white, but also with the much more complex problems of color separation and registration. After his first "key" drawing has been made, each important line must be transferred (most often by a tracing in red chalk) to the separate stones or plates from which each color will be printed. Although the artist necessarily draws in black on all of these stones, he must somehow visualize while working how the first of the stones will look when printed in red, how the second will look when printed in blue and, most importantly, how the two will look when printed together. In a four- or five-color lithograph such a task of visualization presents a challenge even to the most experienced artist.

For Scholder, such a visualization was at first unnatural. In his paintings he was used to working directly in color. He did not first develop a linear image and then determine the color; he *made* the image of color, as a colorist always does. Because of his strong feelings about color, he found it frustrating to have to deal with color in a secondary way.

Powerful as is its image, *Indian at the Circus* reveals this initial frustration. The need to work things out intellectually before rather than during the act of drawing slowed down the creative process, impairing its spontaneity, so that the lithograph lacks the ease and immediacy that are characteristic of both Scholder's paintings and his later color lithographs.

Although a lithograph printed in black from a single stone can sometimes be drawn and proofed on a single day, multicolor lithographs require extended time. Each of the stones or plates must be separately etched by the printer, inks must be mixed and remixed, and proofs must be pulled at the press. These proofs usually reveal the need for minor corrections in order to adjust tiny faults in registration of the images, and the making of such corrections is in itself a time-consuming process.

For Scholder, this first experience with the tedious delays that are an intrinsic part of color lithography was a frustrating one. He had begun *Indian at the Circus* on his third day at Tamarind (Thursday, December 10); by December 23, when the shop closed down for the Christmas holiday, he still hadn't seen it completed. So while proofing moved slowly forward, he worked on other lithographs.

Adjacent to the Tamarind pressrooms and artists' working areas is a large, 25

well-lighted room with many counters and tables. Here the fine papers are prepared for printing, impressions from the presses are examined by the curators, and completed editions are signed by the artists. It is called the curating room, and in many ways it is the heart of Tamarind's life. Here is the indispensable coffeepot; here is a long white wall against which proofs of an artist's work-in-progress can be seen and studied.

Scholder sat on a high stool looking at the six proofs on the wall, the result of two weeks' work: final proofs of *Waiting Indian* and *Indian with Feather,* a proof of a new lithograph, *Indian with Pigeon,* printed from two stones, a deep brown ink softly blending with black. These three worked well together, and although it was still too soon to make final decisions about the suite, he was certain he would include them. The trial proof of *Indian at the Circus* still lacked its final colors; it was indeterminate. The other new images were *Indian Rug* and *Squash Blossom Indian Necklace.*

Indian Rug, he quickly saw, just wasn't working; it would have to be discarded. He felt badly because of the amount of work and effort the printer had put into it; his drawing, he knew, was the simple part. Even so, it had to go. He kept only one impression for his records. *Squash Blossom Indian Necklace* was a two-color print on a special silver paper. Although he liked it very much, he recognized that it might not fit into the suite; its subject and scale were very different. And the printers were obviously worried about the practicality of printing a large edition on the foil paper. Reluctantly, he decided not to use it.

When work resumed after the holidays, Scholder quickly drew the stones for *Kachina Dancers* and *Buffalo Dancer.* In the proofing of *Kachina Dancers,* a three-color lithograph, he first experimented with what the printers call a "rainbow roll" — a technique in which two or more colors are blended together on the ink-slab and the roller, thus gaining a multicolor effect on a single pressrun. Trial proofs were made using many different colors, and although Scholder ultimately chose to print the edition simply in sienna, ochre, and blue-green, the experience of this proofing session opened the way to later lithographs.

Buffalo Dancer, printed in black on buff Arches paper, was a straightforward image, blunt and assertive. It moved rapidly to a definitive proof, a proof which was absolutely right, which fully met the artist's intentions. Such proofs, following long tradition, are designated *bon à tirer* impressions: literally, "good to pull." Around the shop they are called BAT's. Once the artist signs and approves the BAT, his work is done. It is then the printer's task to run the edition, carefully comparing each impression to the BAT to assure its quality.

When the edition is completed, again by long tradition, the *bon à tirer* impression will become the printer's property.

In the case of Scholder's lithographs, no edition could be run until the prints for the suite had been finally selected. It was time for a conference. Again a proof of each lithograph was put on the study wall. No one wished to hurry Scholder; an artist should never sign a *bon à tirer* if any question remains. On the other hand, it would take many days of press time to run the editions, and unless a start were soon made there would be problems with the workshop schedule. When a drawing is on a stone it must be held until either the edition is completed or the image is abandoned. A number of the workshop's large stones now bore Scholder's drawings, and thus could not be regrained for further use until some decisions had been made.

There could be no doubt about four of the prints. *Waiting Indian, Indian with Feather, Indian with Pigeon,* and the new *Buffalo Dancer* should definitely go forward. One, *Kachina Mask,* Scholder decided to abandon.

The spirit of the first four lithographs selected for inclusion in the suite was calm and monumental; there was none of the acid bite and wry humor which are often a part of Scholder's work. No taboos had been broken.

Indian at the Bar came next. This was a different Scholder. "People say that I must hate Indians since I sometimes paint them as monsters. But I paint what I see, faces reflecting the torment in the minds of Indians today, torment resulting from the impositions on them of contemporary American society."

The figure of the leering Indian, wearing dark glasses and a wide-brimmed hat, sits leaning on a bar. Set forth abstractly in bold areas of black, buff, and gray, the figure contrasts sharply with the concreteness of the beer can. Drawn and printed in full color, the beer can is *real,* the Indian an apparition. What could be more real in Gallup than a can of Coors beer?

Among all of Scholder's images, *Indian at the Bar* is one that most bitterly haunts the memory. There was to be no question as to its place in Indians Forever.

With *Indian at the Circus* and *Kachina Dancers* both now proofed to conclusion, seven of the suite's eight prints had been finally determined. Scholder again reviewed all that he had done since beginning work at Tamarind three months earlier. There was a fine *Self-Portrait,* but it, like *Squash Blossom Indian Necklace,* had to be printed on foil. A bold, large head, later called *Wild Indian,* had been proofed in a number of brilliant color variants. There was a brush-drawn, black-and-white *Indian Dancer.* But none of these seemed quite right as the final print for the suite.

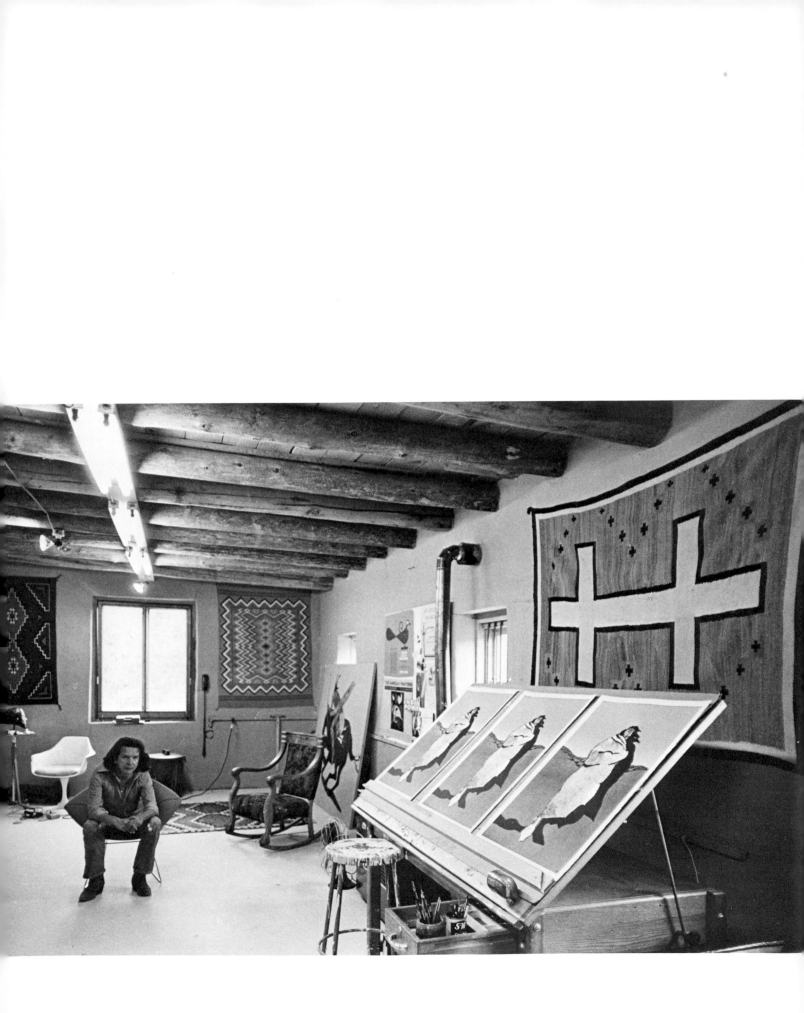

So stones were again prepared, and on March 22 Scholder came again to the workshop, this time to make the drawings for *Indians with Umbrellas.* The subject was conceived in a horizontal format, lending balance to the suite. Working with printer John Butke, Scholder sought to use the "rainbow roll" to convey a sense of the radiant atmosphere that follows a southwestern thunderstorm. The row of mounted Indians, the umbrellas held high against the tusche wash sky, and the texture of the grassy foreground combine to assert the artist's now certain command of the lithographic medium.

In all, by the end of March, Scholder had undertaken a total of twenty-one lithographs. Eight of these had been chosen for inclusion in Indians Forever; one other, *Abiquiu Afternoon,* had been printed in an edition of fifty impressions; three had been abandoned. The remaining nine lithographs existed in a varying number of trial proofs or lettered impressions. Because of a disagreement between the artist and his publishers, these extra images, including *Wild Indian* and the *Self-Portrait,* were never to be printed in editions — an unhappy consequence in view of their quality.

Well before completion of printing, work was begun on the design of the folio. Two were made, both cloth-covered. One was brown, of a coarse hemp weave; the other in red, much finer in texture. Scholder preferred the roughness of the brown one. The wording of the colophon was then determined. It would provide full information as to the number of impressions and the fine papers that had been used, and would list the names of the printers. Both the colophon and the title page were to be printed from handset type by the distinguished California typographer Saul Marx.

Finished editions were now moving from the pressroom to curating. There, each impression was again examined. Tiny flaws and inconsistencies in printing often become visible only after the ink is partially dry. It is the curator's task meticulously to inspect each impression, again comparing it with the artist's signed *bon à tirer.* Those that do not pass inspection must be destroyed.

Indians Forever was to include a numbered edition of seventy-five impressions, five roman-numbered impressions, and six artist's proofs. Additionally, there would be two Tamarind impressions, to be retained by the institute for study and exhibition, and a miscellany of trial proofs and color trial proofs. All of these were carefully documented and recorded.

Scholder signed each impression. Despite the assistance of Tamarind's curators in the handling of the prints, it was a formidable task. There were more than nine hundred impressions in all.

The Tamarind chop was put on each lithograph. Use of such a chop, or

blindstamp, is a well-established custom, serving not only to identify the workshop in which a lithograph is printed, but, more important, to stand as assurance of the lithograph's high technical quality. The Tamarind chop, derived from the medieval alchemist's symbol for stone, joined the individual chops of the printers and the artist on each lithograph.

Everything was once again checked and rechecked. All was in order. The final step could now be taken; the stones could be canceled.

Each of the key images was brought back to the press and rolled up with ink again. Scholder marked through the drawings, altering them irrevocably. A single impression of each was pulled, the "cancellation proof," which serves as a record of the image's destruction. The stones could now be regrained for other work. The project was completed.

Returning to Santa Fe, Scholder recalls, his feeling was one of excitement "not only about the lithographs, but about everything — the portfolio, the title page and colophon with their fine typography. It all combined to make a fine presentation of my original concept. I felt the suite had great traditional importance; I was also excited by the fact that these lithographs would reach a new audience, and that I had found a new medium in which to express my ideas. I knew I would do many more lithographs in the future."

IV

During the spring and early summer of 1971, Scholder worked full-time in his studio. Painting followed painting, more paintings of Indians, and also the first of a new series of American Women.

"The most misunderstood minority in this country is the American woman. . . . I want to show the real, the raw woman. She can become monstrous — but just as with the Indian, that ugliness is part of the reality . . . deKooning did women that were so monstrous, so heavy-handed that they almost failed. I don't think they did," he adds. But as in deKooning's *Marilyn* or his girl with the toothpaste smile, Scholder sees (and condemns) the cosmetic falsity that society expects of women. "The fashion people today are preying on women.

"More and more I realize that everything is a cliché — women just as Indians. This is the main thing that the painter, or any intellectual, is always fighting: the world of the factoid, the world of things that seem to be real but aren't."

But Scholder's woman, like his Indian, is very real indeed. Sprawled bare-breasted in a bucket chair, her legs spread wide apart, her hair blowing in an unseen breeze, Scholder's woman is all female: by Kenneth Clark's distinction, she is far more naked than nude.

She appears five times in the thirteen lithographs Scholder completed during his second session at Tamarind during August of 1971. In the first of these, *Indian with Woman,* she leans insolently, hip thrust out, behind the Indian's chair; in a second she wears the head of a cat (is she an Egyptian goddess, or "O" in her owl-feathered mask?); in a third she stands entwined by phallic snakes. Never is she clothed. Presented in abstract form, as in *Squatting Woman,* she is stripped to her essentials, an erotic symbol of her sex. Although occasionally, as in *Woman with Snakes,* suggesting the work of Wunderlich, Scholder's woman is nonetheless his own, a creature of fantasy, sensuous and enigmatic. After that summer she does not reappear in the lithographs.

Also completed in August were eight lithographs of Indians. Five more subjects followed in the fall.

The suite Indians Forever and the other Tamarind lithographs were first exhibited as a group in Santa Fe at the end of November. It was a gala evening, despite a cold and bitter wind. There had been an early snowfall, and ice still lay on the sidewalks around the historic plaza. Margaret Jamison's gallery was thronged with people, elbow to elbow.

The prints were impressive on the walls. But even more impressive was the fact that so large and convincing a body of work could have been brought into being in so short a time. The last of the prints, the haunting image of a *Pueblo Dog,* was Scholder's thirty-ninth lithograph since he had begun work at Tamarind, slightly less than a year before.

In the spring of 1972 Fritz Scholder and his wife Romona purchased a small adobe house in Scottsdale. In early summer they bought the hacienda in Galisteo. Inevitably, they faced the complications of moving, but Scholder did not interrupt his work. May of 1972 saw him again at Tamarind, and although he made but three prints, it was an important period. A lovely portrait of Romona was to serve as her birthday present later that summer. And *American Indian No. 4* was to mark a turning point in Scholder's use of color in lithography.

It was the first time he had drawn a color lithograph without a single key image. Printed in red and blue, both stones carried equal weight. "The blue became a mass, the red became a mass, and the washes overlapped. At that time it was quite a thing for me."

Despite his excitement at this new use of color, Scholder felt misgivings. It was such a "printerly" print. He was worried that he might be responding unduly to the enthusiasms of the printers. He knew by then that they tended to be carried away by technical complexities for their own sake. He didn't feel exactly pressured to move in the direction of such complexities, but even so, he could sense their attitude. Wow! they seemed to say, now Scholder is really doing things! But that wasn't his intention. "This print may have been my homage to technical lithography. But I know that my approach to the medium is quite different. At first I was a little ashamed of it — it seemed so very simplistic — but now I accept the fact. I am not really a printmaker in any narrow sense of the word."

American Indian No. 4 was also the first of the lithographs to make use of the Indian and the flag. Scholder had used the motif before in his paintings; he would return to it again in future lithographs: an Indian figure draped in a flag — an American flag.

"I am pleased when a paradox is established, because I think a good work should be able to be seen on different levels." But at the same time Scholder rejects the notion that his intent is to convey a message. "People have called this a kind of political commentary, whereas in reality it was simply a common sight in the late 1800s. The commissaries on the different reservations had been sent surplus supplies of American flags — for no-one-knows-what reason — that's the way the government works. Anyway, they gave the flags out to the Indians, who immediately realized that they could be used as a decorative part of their costuming. It wasn't because they were patriotic. They had a design sense long before the hippies."

V

No stereotype, not even that of the flag, is more pervasive than the popular perception of the artist in America. A romantic, irrational creature, he creates in moments of ecstasy, while living *la vie de Bohème*. In glorious Technicolor, perhaps played by Charlton Heston, he is the ultimate cliché.

This nineteenth-century myth has a dual attraction for Middle America. Although condemned for his improvident impracticality (and probable immorality), the artist is at the same time a symbol of unrealized desires: a Walter Mitty dream of Tahiti and Bali Ha'i.

Sharing in this myth, the Indian, like the artist, is an outsider. Both are misunderstood. Between *Hiawatha* and *Lust for Life,* which is the more unreal?

In Scholder's view, "it is a sad thing that these myths have developed." Rejecting the romantic view of both the Indian and the artist, he sees no need either for the Indian to conform to stereotypes or for the artist to starve while living in a garret.

Scholder's approach to his work and his career as an artist is intensely practical. He sees no problem in combining his creative work as an artist with a businesslike attitude toward the exhibition and sale of his paintings and prints. "There is no conflict," he says. Too many artists permit themselves to be imprisoned by the myth. "There are painters who scorn or put down those who buy their work. This just doesn't make sense. It's not that you have to sell out, it's not that you have to play what I call the show-biz game. But when contemporary artists say things against the business aspects of their work, well, it's really through their teeth. . . . Your own inspiration or validity as an artist is a separate thing. That is what you do in the studio. You can only answer to yourself for that."

Such intelligent realism is central to Scholder's character. He accepts the facts of life. He accepts the fact that the act of painting is a solitary act, done by the artist in his studio alone; but that the *whole* life of the artist comprises a broad range of experience, including openings and receptions as well as conversations with collectors and clients. He moves with ease from one world to the other, just as he moves with ease from the Indian pueblos to the salons of Santa Fe, Scottsdale, and New York.

Warm and open in conversation, Scholder is at the same time somewhat reserved. This is seen at Tamarind. Many of the artists who come to the workshop develop a close social relationship, a camaraderie, with the printers. Scholder's posture is strictly professional. "Yes," he agrees, "I've noticed that some artists are very friendly with their printers. They are always talking with them, or spending evenings with them, whatever. I've kept my distance. I'm sure some people may think I'm snobbish, in a way. But I'm a very shy person, and I'm really there to work."

Nowhere does an artist reveal himself more directly than through a self-portrait. Scholder has made a number over the years, including five among the lithographs. Together, more than separately, these prints form a portrait of the artist: the serious, straightforward Scholder seen in the first *Self-Portrait* of February 1971 is quite different in attitude from the *Laughing Artist* of 1974. "It is kind of a clumsy figure, not campy really, but it has a certain quality — I'm

almost poking fun at myself." Both are in sharp contrast to the compelling intensity of *Screaming Artist,* in which the face becomes a mask of rage.

"I suppose the prints — and all my works — are autobiographical, although often in the most abstract way. I find — and this is not unique with me — that I can use the traumas of my personal life to enhance and bring strength to my work. If some artists have an emotional trauma they either stop working or their work goes downhill. But my work has never suffered. At times when things get too staid, I almost *bring on* a personal trauma so that I can get the kind of a shot in the arm that is needed for my work.

"I don't like to psychoanalyze myself, and I can't be literal about the things that influence my work. *Screaming Artist* can be taken however anyone wants to take it. It is one of those prints that I did especially for myself. I thought no one else would like it.

"There are times," he adds, "when I walk into the workshop, when I feel a certain way, and it is a nice kind of catharsis to be able to take a little stone — or even a big stone — and put it all down, just the way I feel."

VI

In addition to his paintings and lithographs, Scholder sometimes makes fetish sculptures.

"I remember," he says, "while I was still teaching at the Institute in Santa Fe, I sent a fetish piece to an exhibition at a nearby college. When the show opened the gallery received threats that if it wasn't removed it might be destroyed, or that a demonstration might take place."

The piece was a manikin. Scholder had painted it, draped a piece of Navajo blanket over its shoulders and given it an Apache hat. The Indian students who objected clearly felt that despite its conglomerate character the piece came far too close to a traditional form: an object with real power.

The quality of magic which the students perceived in Scholder's fetish piece is important to him. "What they were saying was really quite a compliment to me. In a way it meant that I had gotten close to being a medicine man myself."

Art and magic, in this sense, have much in common. In ways that cannot be rationally or logically described, both strongly affect the feelings of men. Scholder speaks of an impressive fetish which he later saw: "It was one of the great altarpieces of the Crow tribe — one of the greatest fetishes of the American Indian: a huge mummified eagle hanging from a tripod, covered with

gunk and feathers and hides. It was one of the most beautiful things I have ever seen."

When the German Expressionist artists, particularly Kirchner, became interested in African and Oceanic sculpture during the early years of the twentieth century, it was the emotional intensity of these pieces, not their formal structure, which was paramount. So it is with Scholder and the fetish. "Whether I make an object, a lithograph, or a painting, it is terribly important for me that it have a kind of personal magic. Because, really, that is the only way that any so-called art has value."

In none of the lithographs is a sense of magic or mystery more tellingly conveyed than in *Galloping Indian No. 2*. More spirit than real, a phantasmal horse strides forward toward the viewer, its face-guard a startling white. Described in violet and black, the horse and its Indian rider present a strange vision of another and distant world. Nor can Scholder add words to explain the image. It remains mysterious.

"I love the paradox," he says. In art as in life, all things need not be spelled out. "In today's cybernetic age one can still make fetishes. It seems to me that instead of depicting the noble savage hunting the buffalo, Indian artists — artists of Indian descent — should look toward the powerful medicine and magic of the fetish as their inspiration.

"In the world in which we live today, so many things have been destroyed, so much that we believed in. One of the few things left to believe in is magic. This may sound cynical, but in a way it is very positive. What is known as magic is, in essence, the sum of things we do not know. This is the area of optimism, the area of interest to the creative scientist or the creative artist."

No one can really say from what source the magical qualities of art may derive, nor how they come to be. In Scholder's work, however, such qualities are directly linked to spontaneity. *Galloping Indian No. 2* all but flowed from his brush. The drips and spatters of tusche were left untouched as they fell, although in a lithograph, unlike a drawing, such evidences of the artist's hand can easily be removed when the stone is prepared for printing. Scholder characteristically chooses not to do so. Spontaneity is for him an indicative clue. The more immediate his work, the less he has to alter, change or reenter it, the more likely its success.

Many later lithographs share with *Galloping Indian* this sense of immediacy. Often they are subjects long filtered through Scholder's memory, as is the case with *Dakota Winter Night No. 2*. The dark figures of the Indian riders are obscure and evocative, creatures of history, dreams of the artist's youth, their faces more felt than seen. "It just came about," he recalls.

Dakota Winter Night No. 2 is but one of many lithographs which Scholder has chosen to publish in more than one version. Often there is a larger edition printed in two or more colors, and a smaller edition printed in black alone. At times there are variant editions, both or all in color.

The possibility of the simultaneous existence of such alternatives opens many doors for the artist. In a painting the choice is either/or. The background can be orange or it can be green. In lithography, proofs can be printed in both colors and placed on the wall, side by side. If the artist so chooses, *both* can be retained.

"I try to stay open," Scholder says. "I have a first conception, but often, after working for a while, trying different colors in proofing, for instance, I come to a realization that the image can work well in another way. I am a colorist. I always like to print in color."

It is of interest to compare Scholder's black-and-white lithographs to those printed in color. At times Scholder conceives a print in black and white. At other times he plans a subject in color from the start, only to find during the proofing session that a black-and-white edition is also possible. It is not surprising that the most compelling of the black-and-white lithographs are those originally so conceived. *Buffalo* is a print of this character; its spontaneous brush drawing and the simple black mass of the animal's body are complete in themselves. Color would add nothing. In *Indian with Red Button,* on the other hand, planned as a two-color print, the black state suffers when compared with that in red and black. Without the brilliant crimson much of the vibrancy is gone. In other lithographs, notably *Buckskin Indian* and *Indian with Feather Fan,* several alternate states exist which have equal success in different ways.

Nowhere are such successful alternatives more clearly seen than in the three multicolor states of *Indian Landscape,* each of which achieves its individual atmosphere. Drawn in the fall of 1974, *Indian Landscape* was published in a total of five states (more than any other Scholder lithograph), two of these in a single color alone. Present only in the multicolor states, the hovering cloud high in the sky above the figures is essential to the spirit of tranquility. As if frozen in history, this gathering of Indians waits calmly and peacefully against the distant horizon, at a happy moment in time.

VII

In the late fall of 1972, the Scholders were again in Europe, this time in Eastern Europe on a tour sponsored by the Department of State. The visit to Romania, to

Transylvania, provided the impetus for a series of small paintings on the vampire theme. A single small lithograph, completed some time later, echoes these paintings and this experience, remaining as part of a still unfinished project. Scholder plans a small artist's book, on fine paper with hand-set type. "I have a preoccupation with death," he says. "The vampire of life is death."

As a student, he recalls, he had been intrigued by the representations of animals in medieval art. He had done research into bestiaries, and had been fascinated by myths and superstitions, by elements of magic. No such myth haunts the mind more than that of the vampire. That will be the theme of his book. "It will happen when it happens."

After his return to Scottsdale, Scholder went in February of 1973 to San Francisco, where within a month's time he completed a suite of four lithographs, Indian Images, at Editions Press. These lithographs, the first to be made in a workshop other than Tamarind (and still the only lithographs he has printed elsewhere), were all in color. Two, *Indian with Flag* and *Portrait of a Massacred Indian No. 3,* remain to this date his largest works in the medium.

Summer found the Scholders again in New Mexico. As always, the stay at Galisteo was accompanied by a period of intense activity at Tamarind. No fewer than fourteen lithographs were completed during July and August. First among these was *Santa Fe Indian,* undertaken as a fund-raising project for the Santa Fe Opera, the artist donating a portion of the edition for that purpose.

It is a memorable image, one of strength and simple dignity. A single, robed Indian figure stands braced against the wind in a landscape of juniper-dotted hills. The lithographic medium becomes a means to an end: the rainbow-roll sky, the passages of tusche wash, and the effective airbrush textures interact in a straightforward way to create a visual statement of power and economy.

It was a hardworking summer: long days at Tamarind, long hours in the Galisteo studio. It passed all too quickly.

Winter followed in Scottsdale again. A new group of paintings under way, travels to the East, and frequent exhibitions. Then again in May to New Mexico.

As in the summer before, Scholder began his work at Tamarind with a print of particular importance, *Buckskin Indian.* Working rapidly, he drew the stones and plates for nineteen editions in May, another nine in September. All in all, a gallery of Indians.

Occasionally, in the work of these two summers, there are images with a mordant tone, as in *Cowboy Indian,* a cigarette between his lips, dark glasses masking his eyes, a Texas hat on his head, transformed by an alien culture. At times, Scholder's wry humor comes again to the fore, as in *New Mexico.* Here in

a single image he compiles a veritable catalogue of clichés: aspen-covered mountains and picture-postcard clouds in a bright blue sky, an Indian figure, "placid, noble and romantic, with a plum-colored face. I felt like putting down every cliché I could think of in regard to New Mexico, and I did it in what I call Fred Harvey style, complete with rounded corners."

But far more often Scholder's attitude toward his Indian subjects is neither bitter nor witty. It is one of simple respect. Impassively standing or sitting, looking directly forward, his Indians confront the present and the future. At times questioning or sad, at times partially in shadow, the faces cause us to reflect upon them, to encounter their meaning, both as visual images and as symbols of our time. If a romanticism is present, it is the formal and expressive romanticism of art history, not the popular romanticism of the American West. Often dressed in ceremonial robes, as in *Buckskin Indian,* the men he portrays are a far cry from the stereotyped figures of the railroad calendars. They would be uncomfortable and out of place in the tourist galleries of Santa Fe and Taos — which is in part the point that Scholder makes.

Each of Scholder's visits to Tamarind now produced a series of new works. He was thoroughly at home with the medium and with the workshop as well. After so many editions no part of the process, technical or psychological, was unfamiliar. Tamarind was at its full capacity, three additional presses having been added since Scholder's first work on Indians Forever in 1970 and 1971. Prints could move simultaneously forward, and as each *bon à tirer* impression was signed, other stones were there to draw upon. His collaborative relationship with Harry Westlund and Ben Adams, the two master printers with whom he now worked most often, had come to full maturity. From previous experience they could anticipate his desires; he could sense their needs. These were very good summers.

When summer ends, fall is golden in New Mexico. The brilliant yellow aspens are not clichés in the landscape, only in bad paintings. And there is a special crispness and clarity in the air which validates the claim to be a "land of enchantment." The word *inspirational* has been all but deprived of meaning in recent years, but as a description of the drive northward from Albuquerque on an October afternoon it is not inappropriate. The piñon-covered mesas, the distant blue rise of the Jemez mountains, the bare crest of Baldy Peak thrusting high above Santa Fe: these can indeed revive the soul. Although out of sight within Tamarind's white walls, this spacious, timeless environment never leaves Scholder's mind. It is there in his lithographs. The land and the Indians.

Unless otherwise indicated, all quotations are from statements by Fritz Scholder in one of two interviews with the author; or in an article, "On the Work of a Contemporary American Indian Painter," published in *Leonardo,* Vol. 6, pp. 109–112, 1973, and used by permission of the publisher, Pergamon Press, Oxford and New York. My appreciation is due to Fritz Scholder for these interviews; to Judy Booth, Assistant Director of Tamarind Institute, and to my wife, Mary, for their helpful comments on the manuscript; and to Kay Wille for her transcription of the tape-recorded interviews.

C. A.

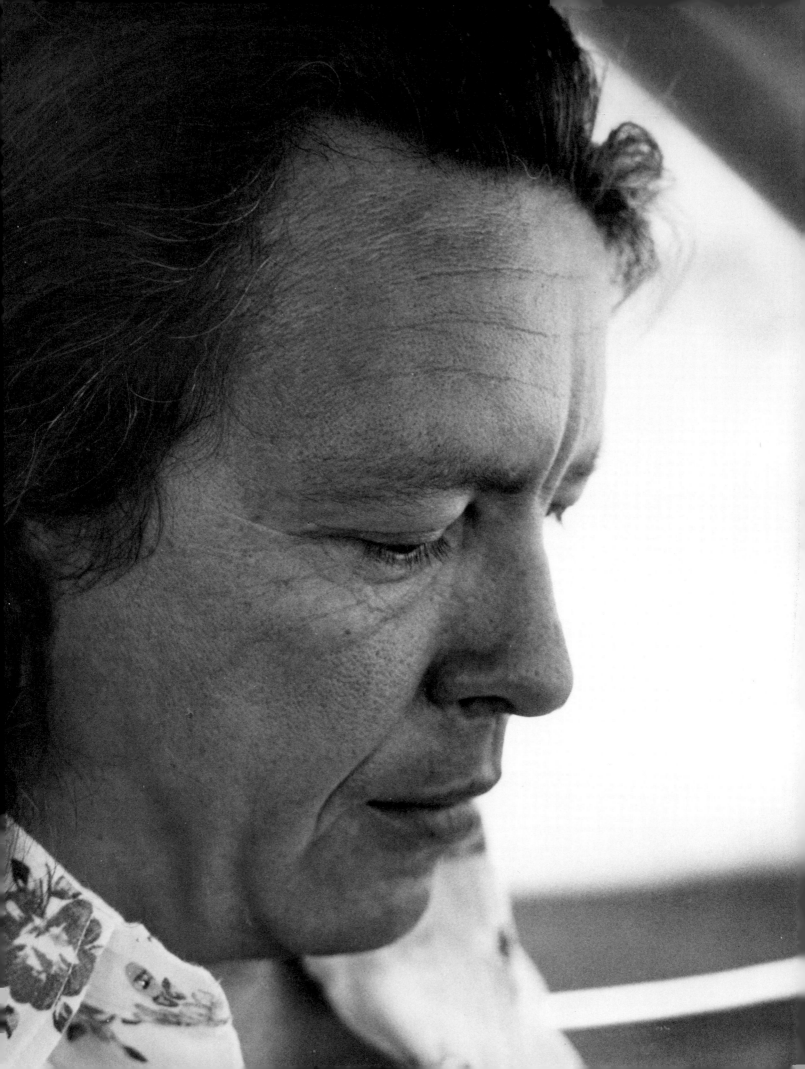

1970

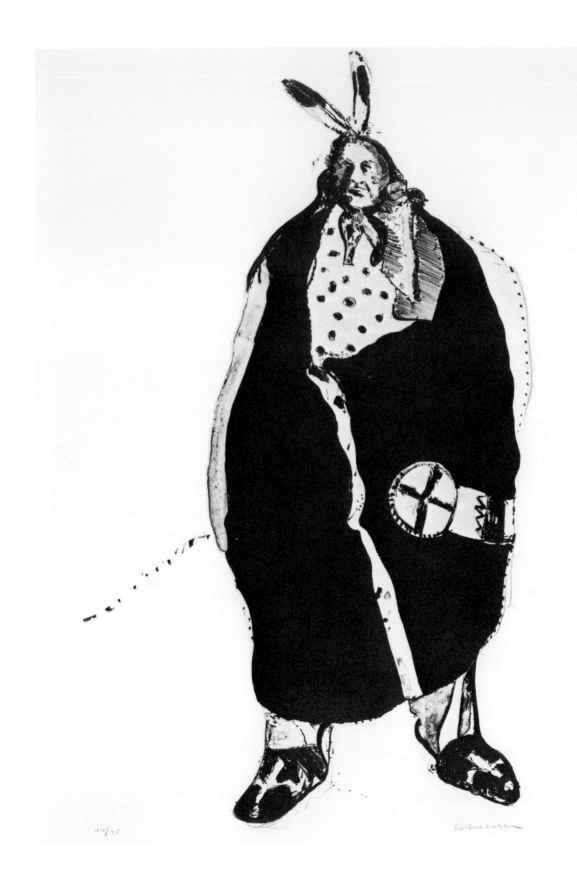

WAITING INDIAN (Indians Forever Suite)

December 1970 [70-183], one color
30 × 22 (76.2 × 55.9), white Arches
Edition: 75 plus BAT, 4TP, CTP, 6AP, 2T, 5R, 2PP, CP
Printed by Julio Juristo

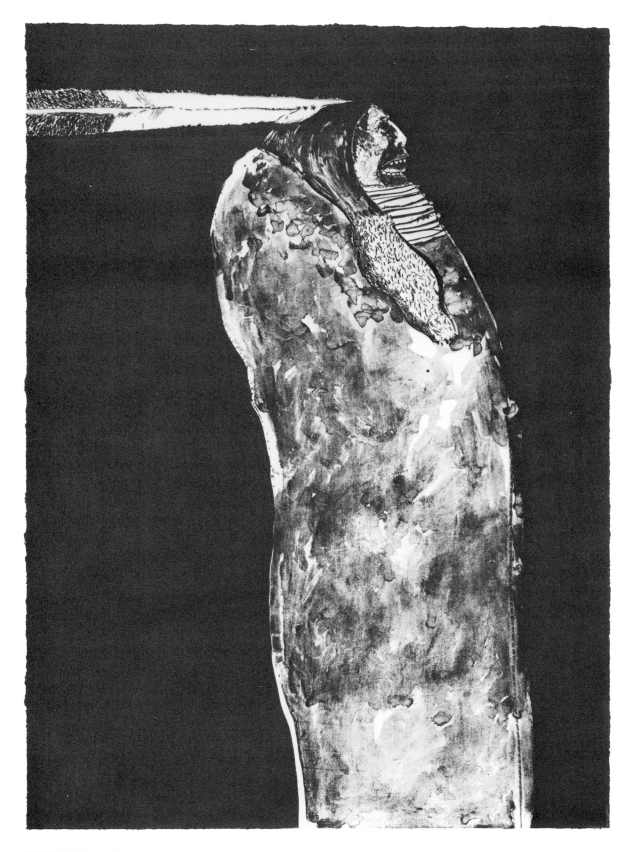

INDIAN WITH FEATHER (Indians Forever Suite)

December 1970 [70-184], one color
30 × 22 (76.2 × 55.9), German etching paper
Edition: 75 plus BAT, 2TP, 2CTP, 6AF, 2T, 5R, 2PP, CP
Printed by Tracy White

INDIAN RUG

December 1970 [70-620]
30 × 22 (76.2 × 55.9)
One unsigned, unchopped impression retained by the artist
Printed by Wayne Simpkins

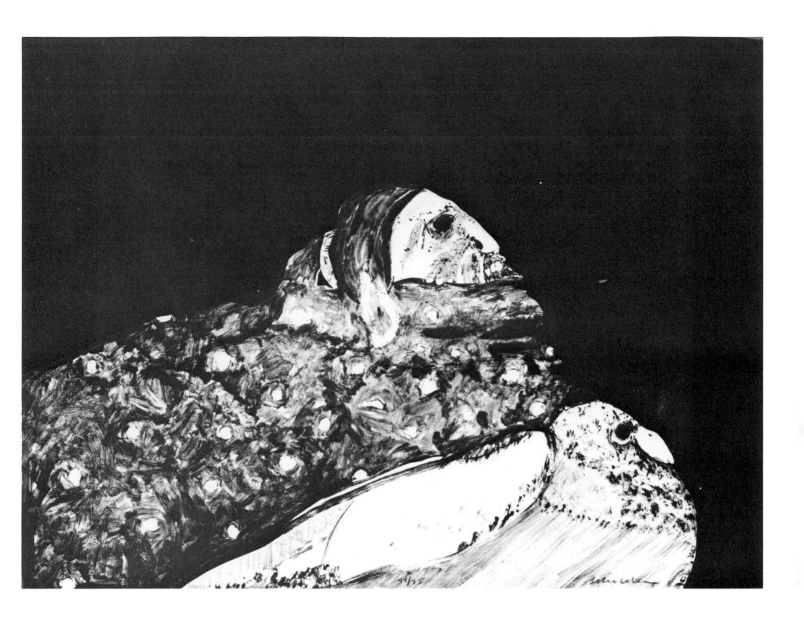

INDIAN WITH PIGEON (Indians Forever Suite)

December 1970 [70-188], two color
22 × 30 (55.9 × 76.2), buff Arches
Edition: 75 plus BAT, 5TP, 3CTP, 6AP, 2T, 5R, 2PP, CP
Printed by Tracy White

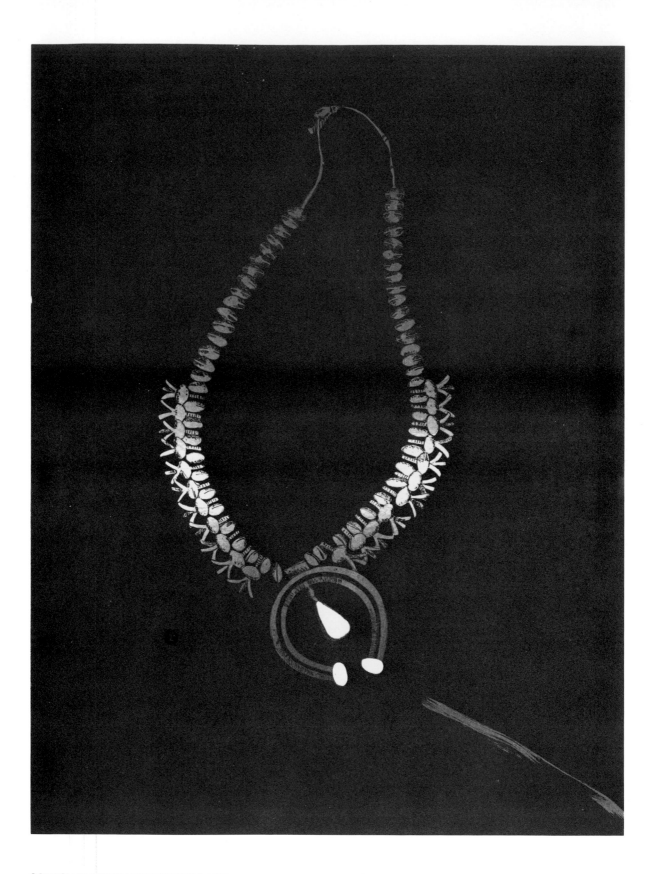

SQUASH BLOSSOM INDIAN NECKLACE

December 1970 [71-612], two color
30 × 22 (76.2 × 55.9), Fasson self-adhesive foil on rag paper
Proofs: CTP, RI, CP

Printed by Tamarind Printer Fellows

1971

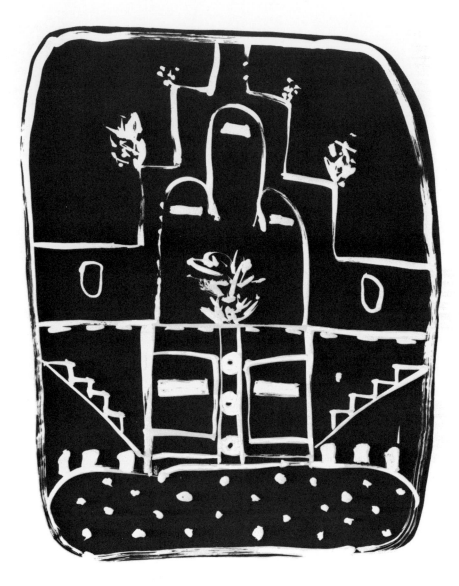

KACHINA MASK

January 1971 [71-639], one color
30 × 22 (76.2 × 55.9), buff Arches
One unsigned, unchopped impression retained by the artist
Printed by Tracy White

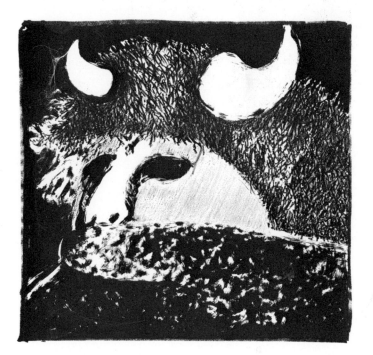

BUFFALO DANCER (Indians Forever Suite)

January 1971 [71-107], one color
30 × 22 (76.2 × 55.9), buff Arches
Edition: 75 plus BAT, 5TP, 6AP, 2T, 5R, 2PP, CP
Printed by Wayne Kimball

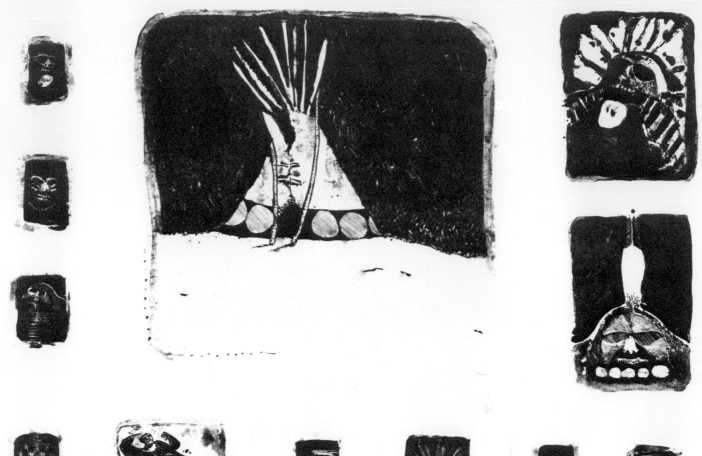

INDIAN NOTE BOOK PAGE

January 1971 [71-613], one color
20 × 27½ (50.8 × 69.8), buff Arches, white Arches; German etching paper
Proofs: 7TP, 7 lettered proofs, CP

Printed by Tamarind Printer Fellows

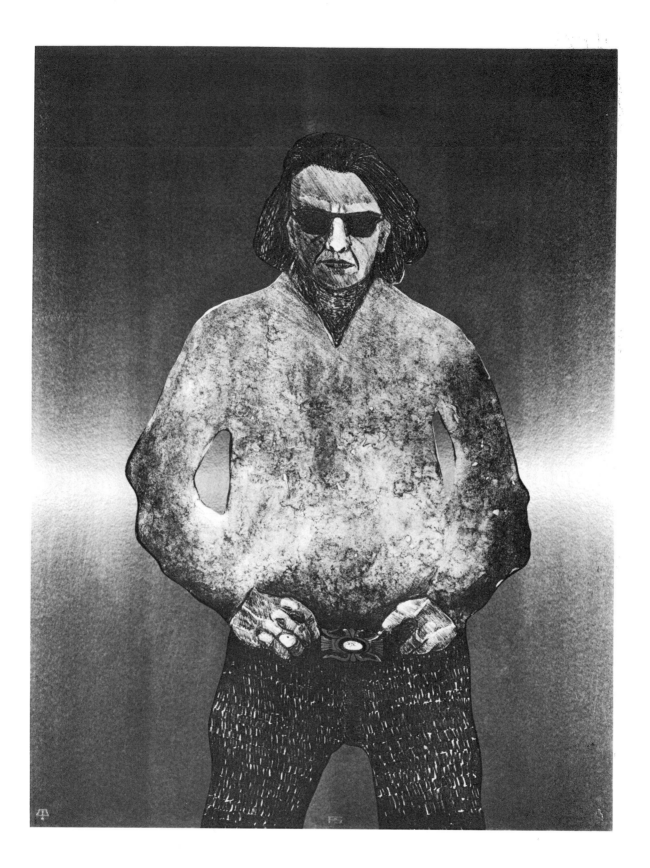

SELF-PORTRAIT

February 1971 [71-614], two color
30 × 22 (76.2 × 55.9), buff Arches, Fasson self-adhesive foil on rag paper
Proofs: TP, 10CTP, RI, CP
Printed by Wayne Kimball

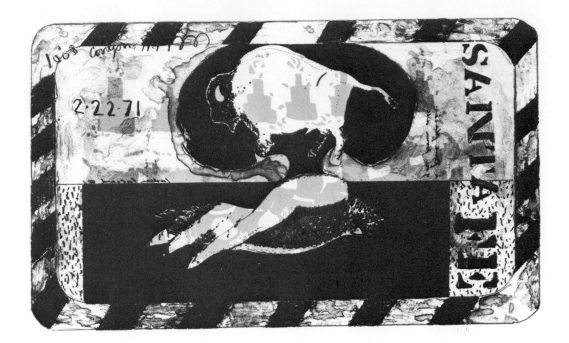

Color Trial Proof Scholder

POSTCARD

February 1971 [71-617a], two color
22 × 30 (55.9 × 76.2), buff Arches
Proofs: 11CTP, RI
52 Printed by Wayne Simpkins

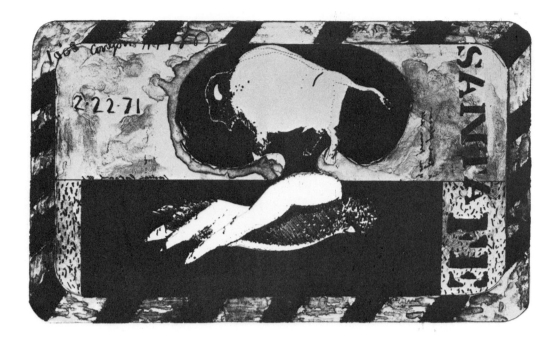

POSTCARD NO. 2

February 1971 [71-617b], two color
22 × 30 (55.9 × 76.2), buff Arches
Proofs: 2CTP, 2RI, CP
Printed by Wayne Simpkins

53

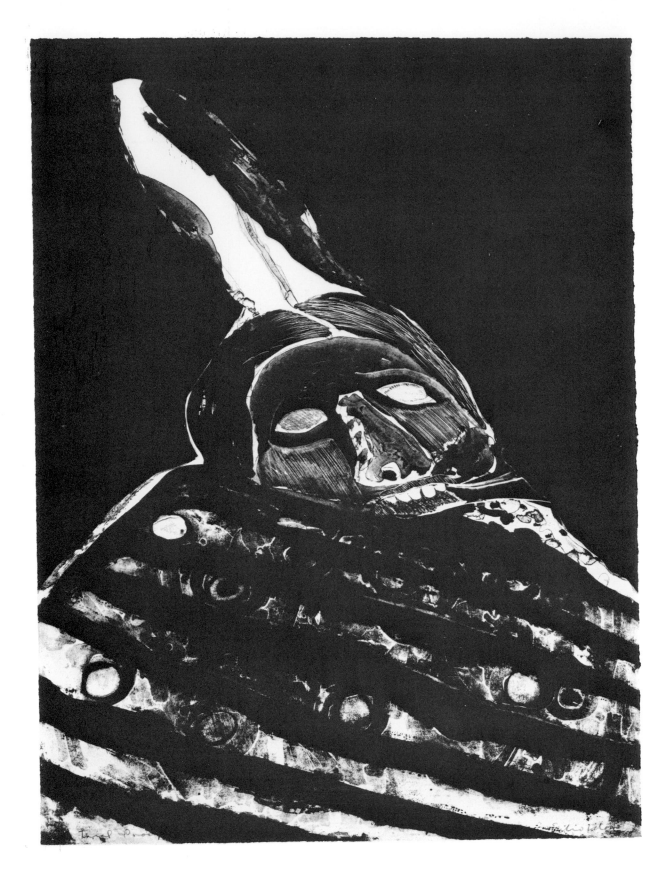

WILD INDIAN

February 1971 [71-616], three color
30 × 22 (76.2 × 55.9), buff Arches
Proofs: TP, 11CTP, RI, 3CP
54 Printed by John Butke

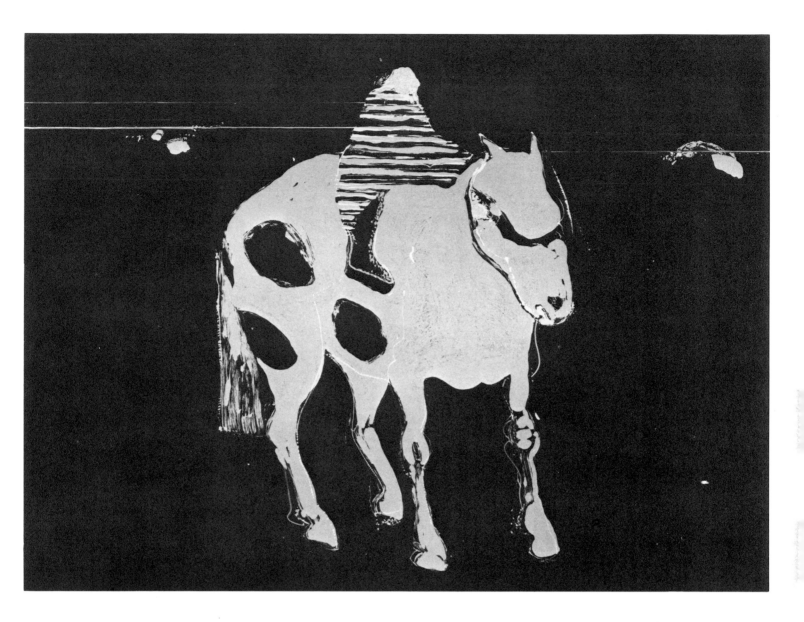

INDIAN AND HORSE NO. 2

February 1971 [71-615], two color
30 × 22 (76.2 × 55.9), buff Arches, white Arches, German etching paper
Proofs: TP, 3CTP, 2RI, 2CP
Printed by Tamarind Printer Fellows

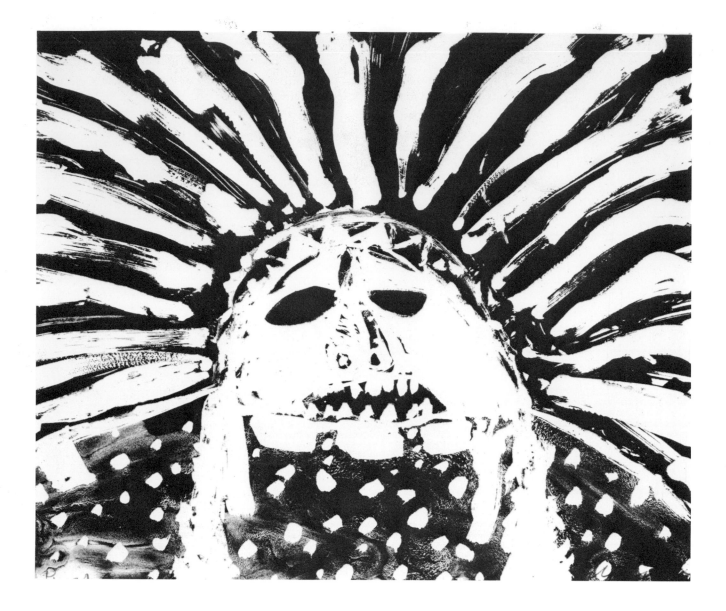

INDIAN CHIEF

February 1971 [71-602], one color
10¾ × 15 (27.3 × 38.1); Magnani Italia, Crisbrook Waterleaf
Proofs: 3 lettered proofs

Printed by Wayne Simpkins

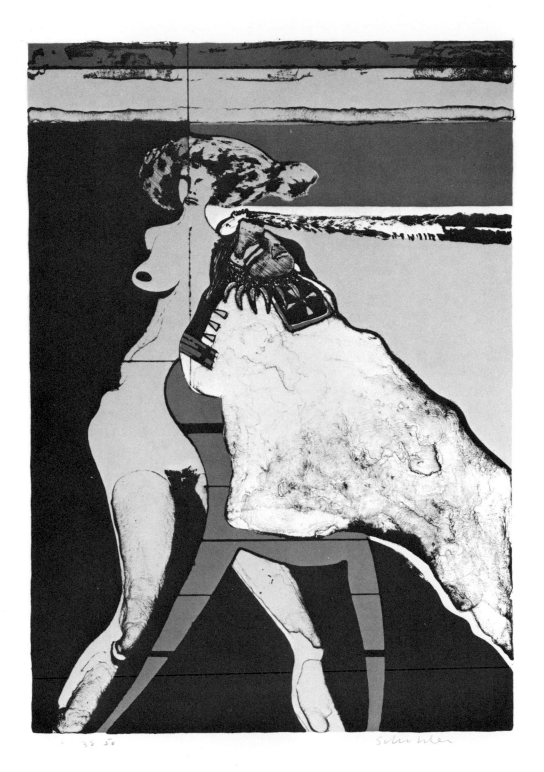

INDIAN WITH WOMAN

August 1971 [71-195], three color
30 × 22 (76.2 × 55.9), buff Arches
Edition: 50 plus BAT, 2TP, 12CTP, 5AP, 2T, 5R, CP
Printed by Wayne Kimball

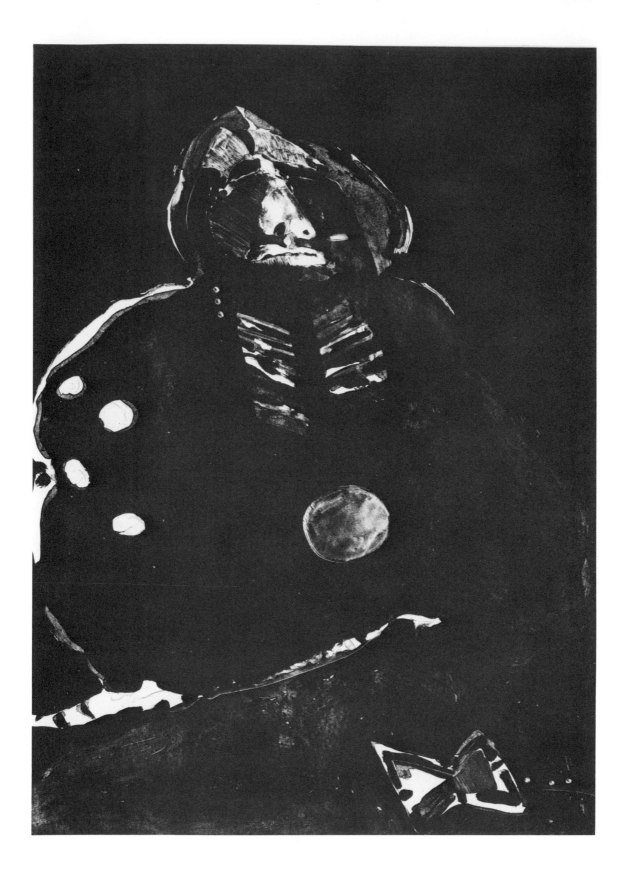

DARK INDIAN

August 1971 [71-619], one color
30 × 22 (76.2 × 55.9), white Arches
Proofs: TP, RI

Printed by Ron Kraver

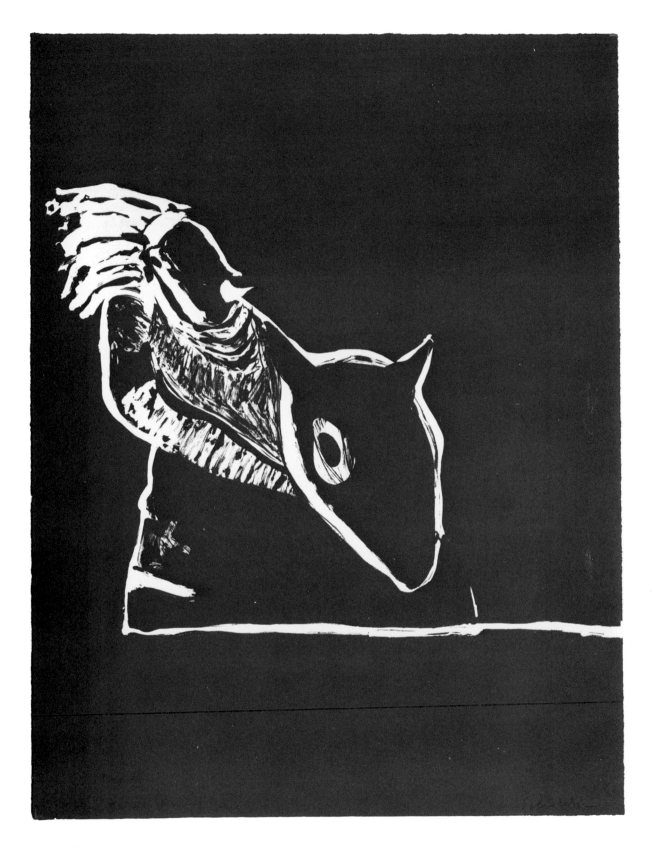

INDIAN ON HORSE

August 1971 [71-631], two color
22 × 30 (55.9 × 76.2), buff Arches; white Arches, black Arches, German
etching paper
Proofs: TP, 10CTP, RI
Printed by Wayne Kimball

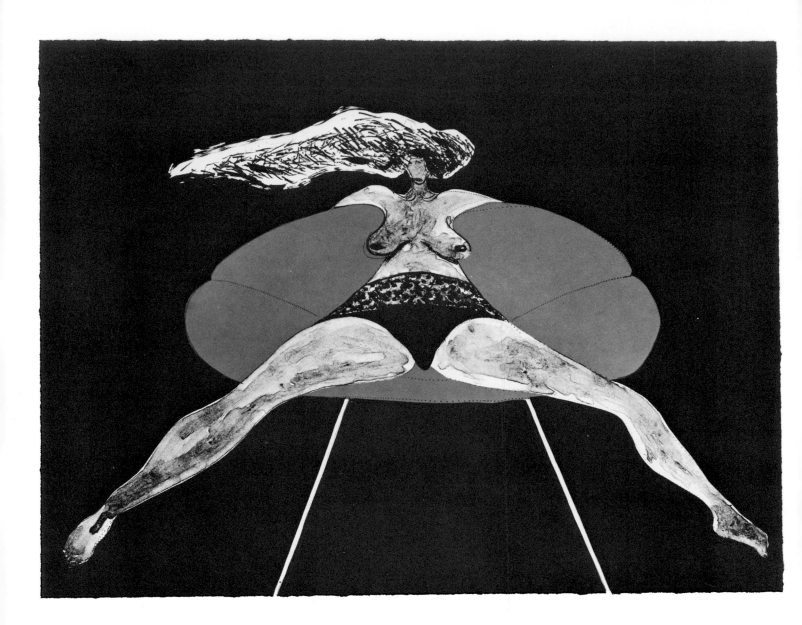

WOMAN IN ORANGE CHAIR

August 1971 [71-207], two color
22 × 30 (55.9 × 76.2), buff Arches
Edition: 50 plus BAT, 3TP, 3CTP, 5AP, 2T, 5R, CP
Printed by Wayne Simpkins

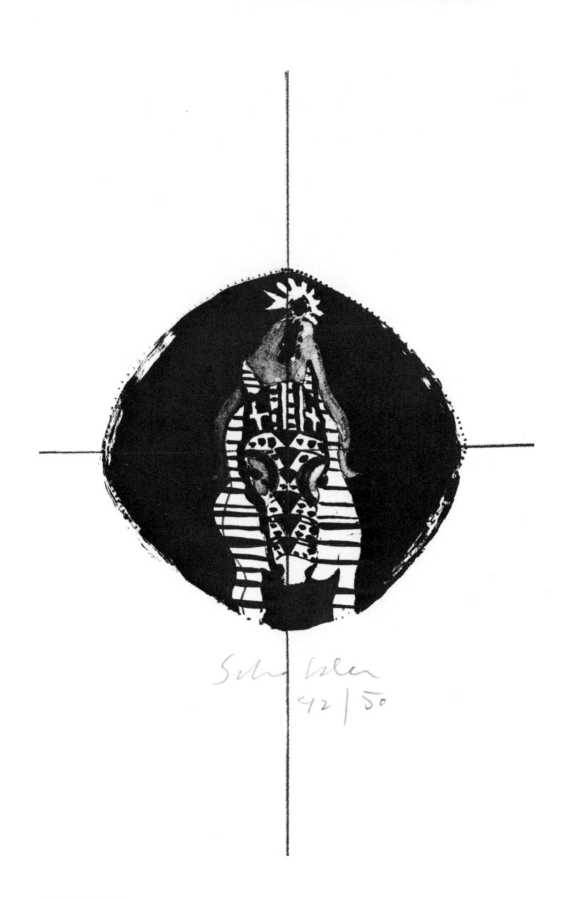

INDIAN TARGET

August 1971 [71-208], one color
11¼ × 7 (28.6 × 17.8), buff Arches
Edition: 50 plus BAT, 3TP, 3CTP, 5AP, 2T, 5R, CP
Printed by John Butke

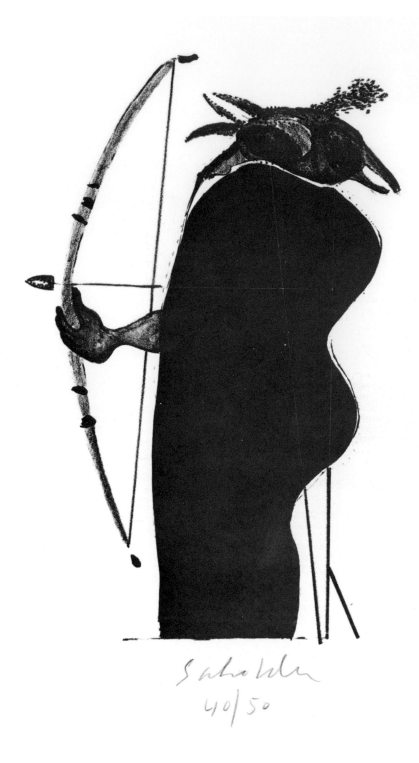

CROW INDIAN

August 1971 [71-209], one color
11¼ × 7 (28.6 × 17.8), buff Arches
Edition: 50 plus 5AP, 2T, 5R

Printed by John Butke

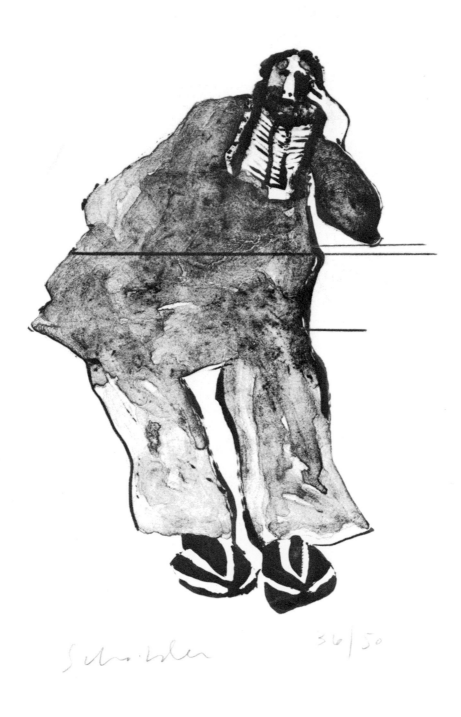

Scholder 36/50

TIRED INDIAN

August 1971 [71-210], one color
11¼ × 7 (28.6 × 17.8), buff Arches
Edition: 50 plus 5AP, 2T, 5R
Printed by John Butke

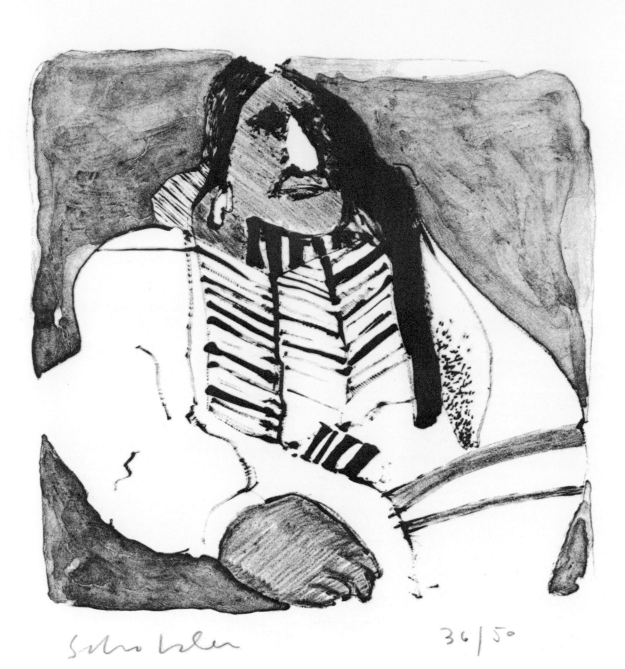

Sobroler 36/50

INDIAN PORTRAIT

August 1971 [71-211], one color
11 × 9 (27.9 × 22.9), buff Arches
Edition: 50 plus 5AP, 2T, 5R
66 Printed by John Butke

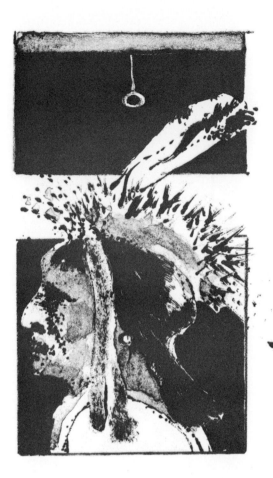

INDIAN AT THE WINDOW

August 1971 [71-212], one color
11¼ × 7 (28.6 × 17.8), buff Arches
Edition: 50 plus 5AP, 2T, 5R
Printed by John Butke

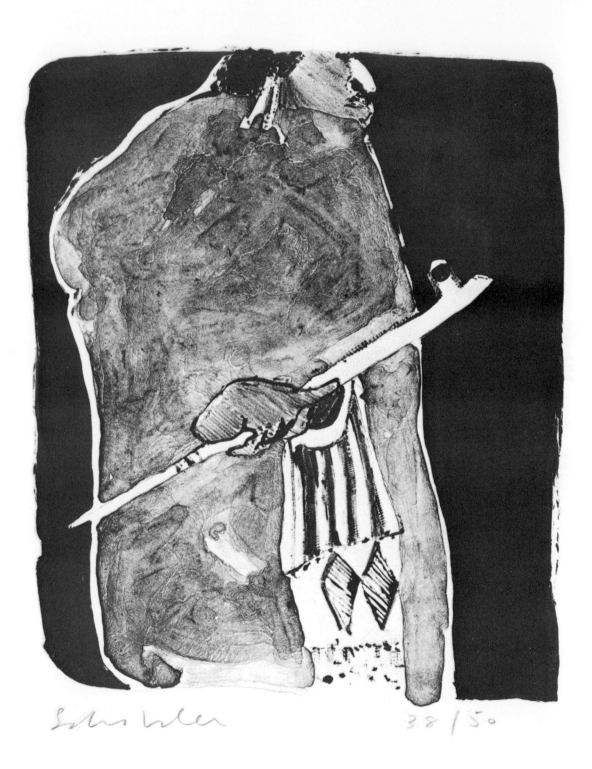

INDIAN WITH PIPE BAG

August 1971 [71-213], one color
11 × 8¼ (27.9 × 21), buff Arches
Edition: 50 plus 5AP, 2T, 5R
68 Printed by John Butke

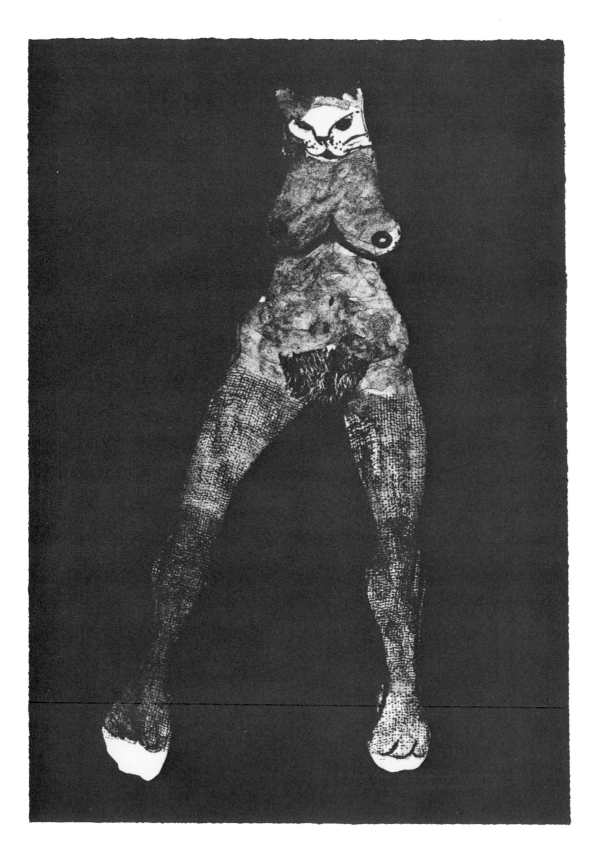

CAT WOMAN

August 1971 [71-214], one color
10½ × 7 (26.7 × 17.8), buff Arches
Edition: 50 plus 5AP, 2T, 5R
Printed by John Butke

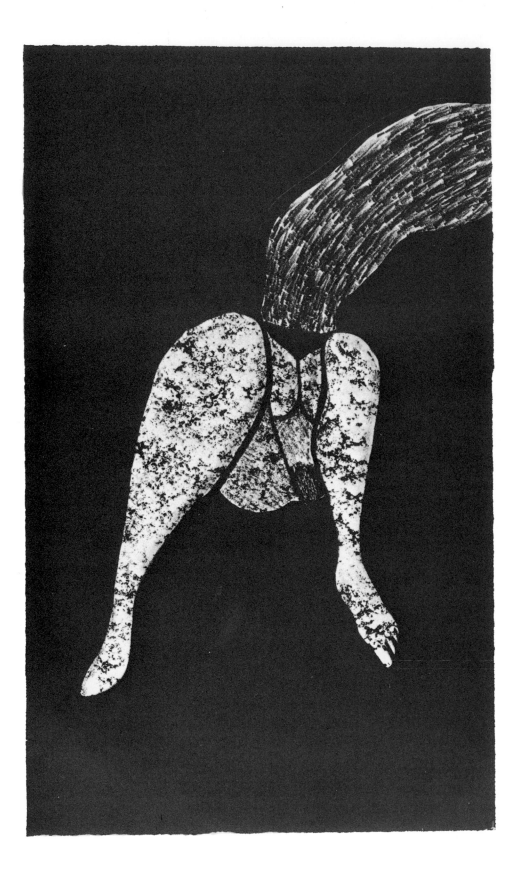

SQUATTING WOMAN

August 1971 [71-215], one color
12 × 7 (30.5 × 17.8), buff Arches
Edition: 50 plus 5AP, 2T, 5R
Printed by John Butke

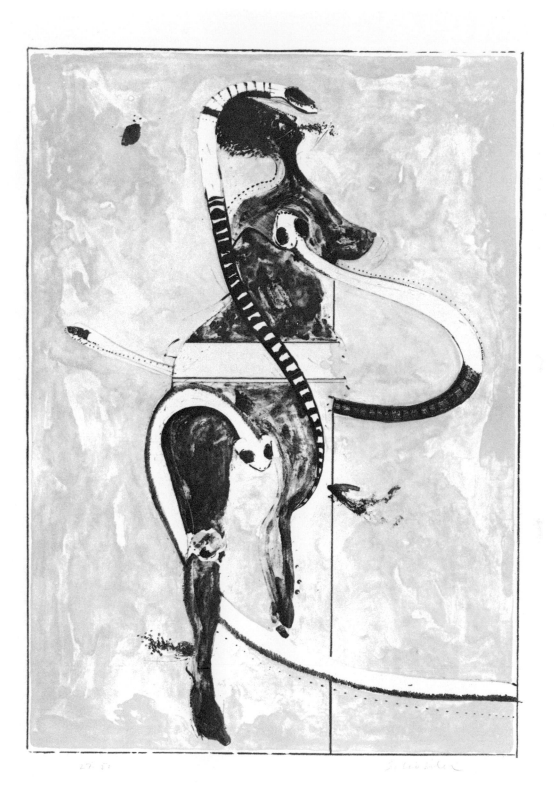

WOMAN WITH SNAKES

August 1971 [71-216], three color
30 × 22 (76.2 × 55.9), buff Arches
Edition: 50 plus BAT, TP, 6CTP, 5AP, 2T, 5R, PP, CP
Printed by Ron Kraver and John Butke

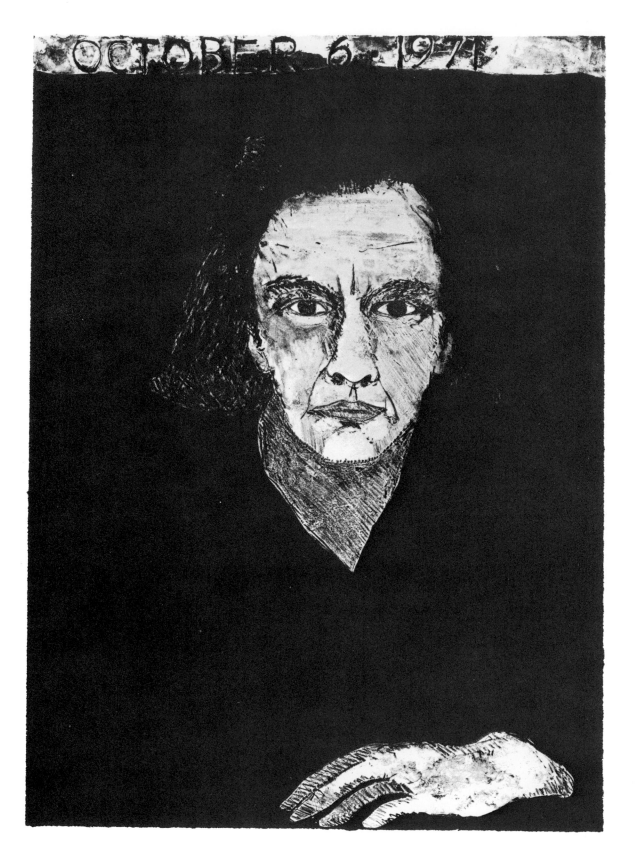

SELF-PORTRAIT, October 7, 1971

October 1971 [71-642], one color
30 × 22 (76.2 × 55.9), buff Arches, white Arches, Nacre, Fasson
self-adhesive foil mounted on Rives BFK
Proofs: 5TP, 4CTP, RI

72 Printed by Wayne Kimball

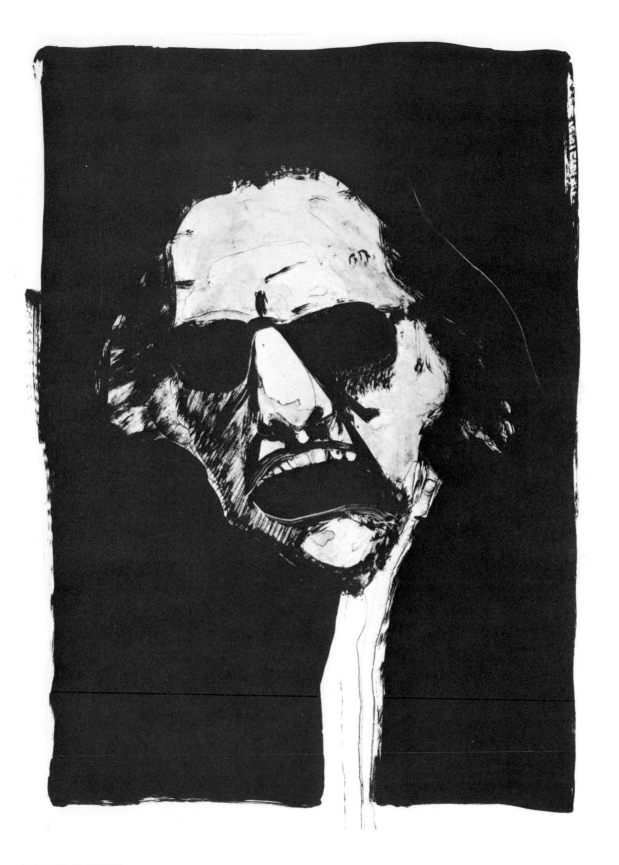

SCREAMING ARTIST

November 1971 [71-223], one color
30 × 22 (76.2 × 55.9), buff Arches
Edition: 50 plus BAT, 2TP, 5AP, 2T, 5R, CP
Printed by Wayne Kimball

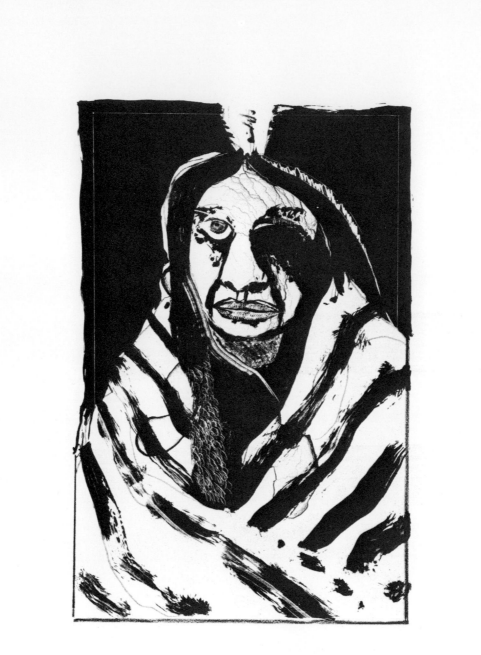

INDIAN WITH BLANKET NO. 1

November 1971 [71-640], one color
11 × 7 (27.9 × 17.8), buff Arches
Edition: 50 plus BAT, TP, 5AP, 2T, CP
Printed by Wayne Kimball

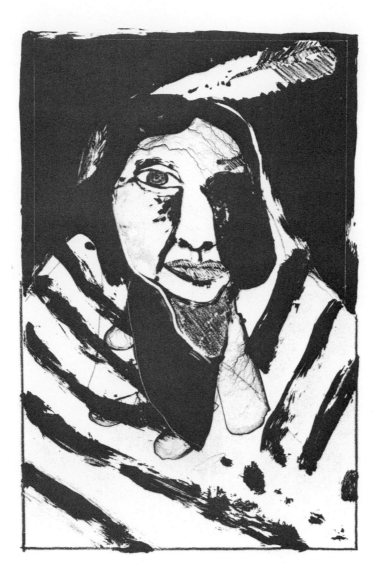

42/50 Scholder

INDIAN WITH BLANKET NO. 2

November 1971 [71-641], one color
11 × 7 (27.9 × 17.8), buff Arches
Edition: 50 plus BAT, TP, 5AP, 2T, CP
Printed by Wayne Kimball

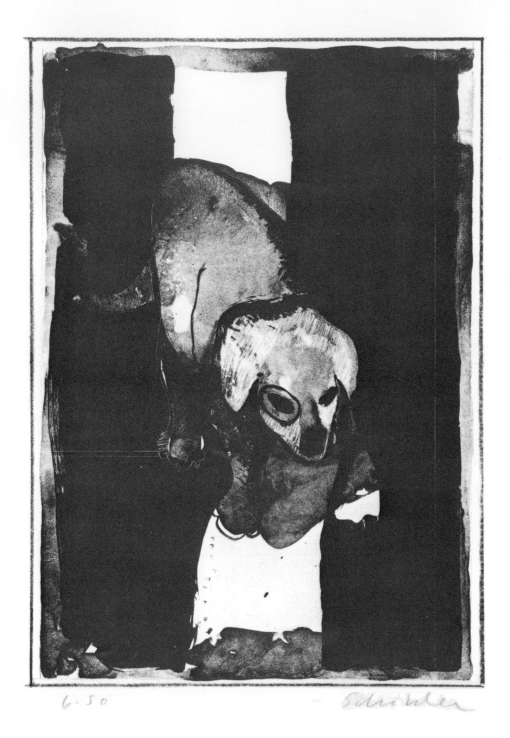

6.50 Schröder

PUEBLO DOG

November 1971 [71-647], one color
15 × 11½ (38.1 × 29.2), white Arches
Edition: 50 plus BAT, 5TP, 5AP, 2T, CP
Printed by John Sommers

1972

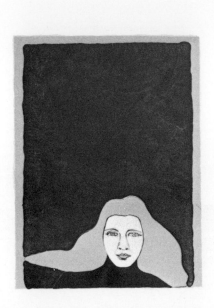

ROMONA

May 1972 [72-206], two color
20 × 18 (50.8 × 45.7), buff Arches
Edition: 50 plus BAT, 2TP, 2CTP, 5AP, 2T, 5R, CP
Printed by Harry Westlund

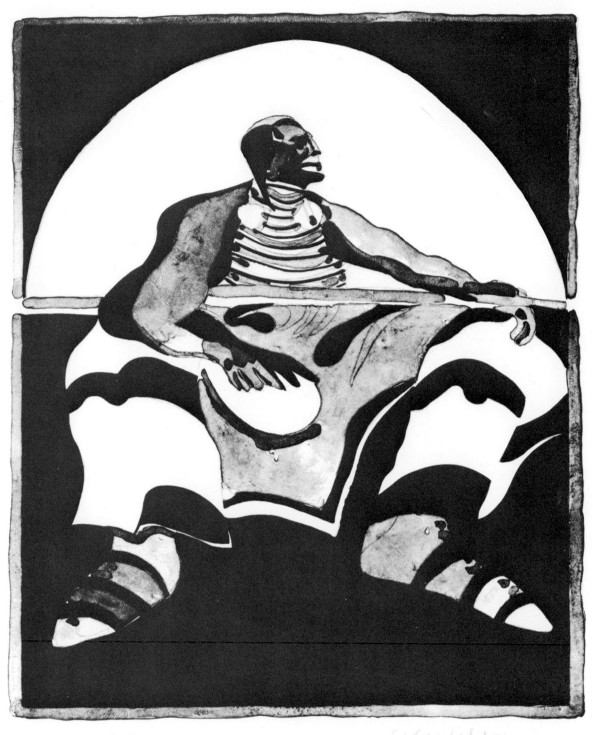

INDIAN IN SPOTLIGHT

July 1972 [72-207], one color
22 × 17¼ (55.9 × 43.8), buff Arches
Edition: 20 plus BAT, 2TP, 2CTP, AP, 2T, 5R, CP
Printed by Ben Q. Adams

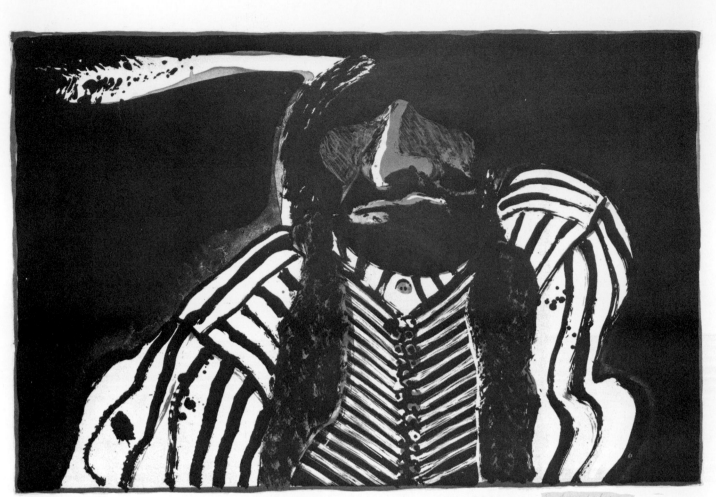

INDIAN WITH RED BUTTON

September 1972 [72-656a], two color
22 × 30 (55.9 × 76.2), buff Arches
Edition: 100 plus BAT, 5TP, 10AP, 2T
Printed by Harry Westlund

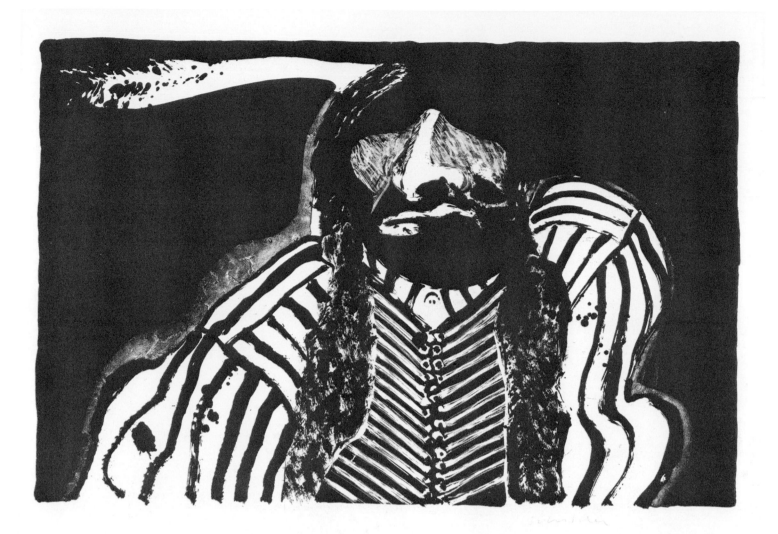

INDIAN WITH BUTTON

September 1972 [72-656b], one color
22 × 30 (55.9 × 76.2), Rives BFK
Edition: 30 plus BAT, TP, 3AP, 2T, CP
Printed by Harry Westlund

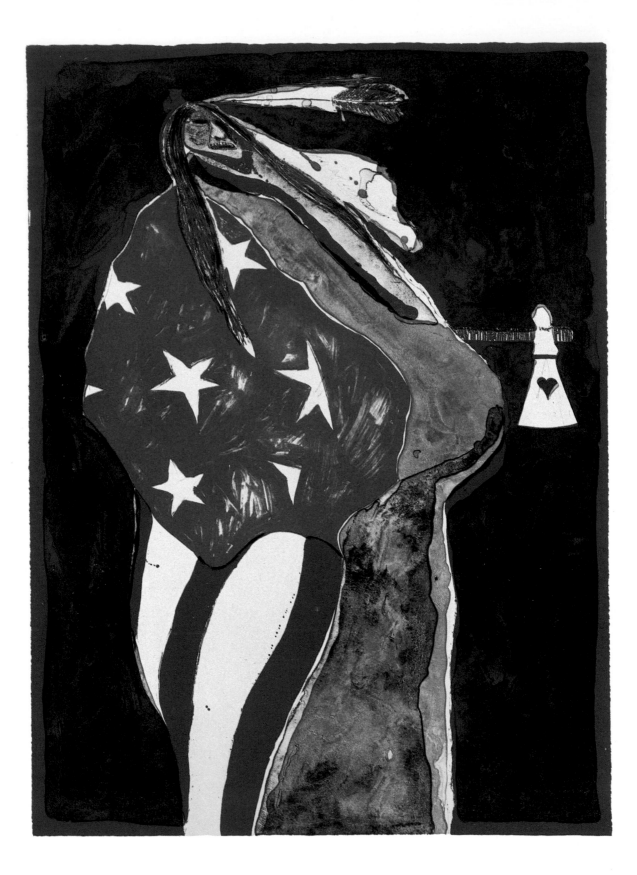

AMERICAN INDIAN NO. 4

May 1972 [72-204], two color
30 × 22 (76.2 × 55.9), uncalendered Rives BFK
Edition: 100 plus BAT, 3TP, 10AP, 2T, 5R, CP

Printed by Harry Westlund

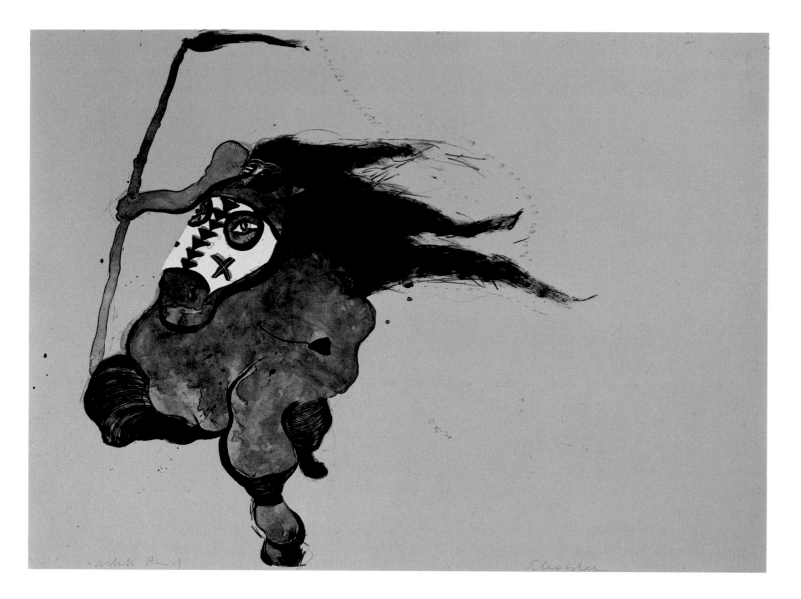

GALLOPING INDIAN NO. 2

May 1972 [72-205], three color
22 × 30 (55.9 × 76.2), uncalendered Rives BFK
Edition: 50 plus BAT, 5TP, 2CTP, 5AP, 2T, 5R, CP
Printed by Harry Westlund

1973

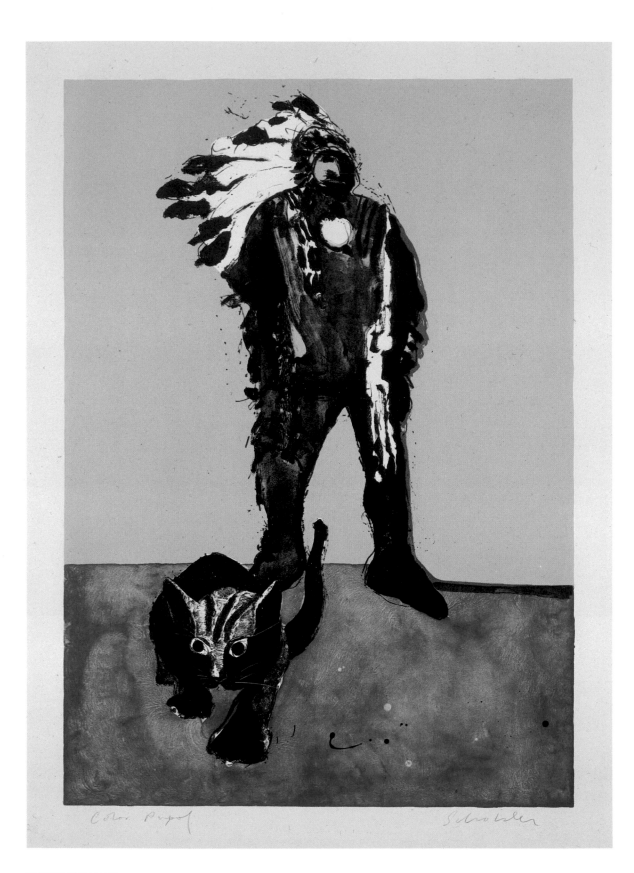

INDIAN WITH CAT

February 1973 [Editions Press 286], four color
30 × 22 (76.2 × 55.9), buff Arches
Edition: 100 plus BAT, 2PrP II, TP, EPAP, 15AP, 4PP, 11EPI, 2SP, CP
Printed by Voorhees Mount

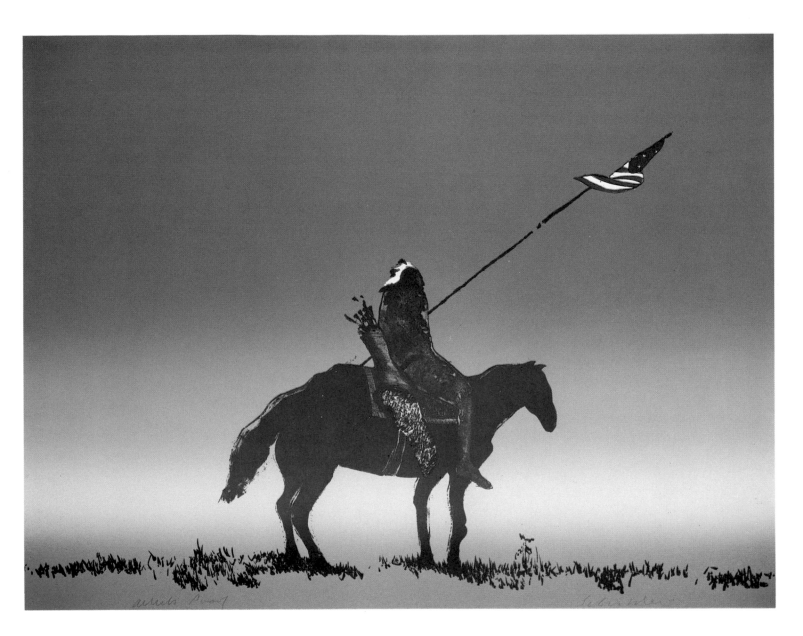

INDIAN WITH FLAG

February 1973 [Editions Press 287], six color
30 × 39 (76.2 × 99.1), Rives BFK
Edition: 100 plus BAT, 2PrP II, TP, EPAP, 15AP, 4PP, 10EPI, CP
Printed by Ron Adams

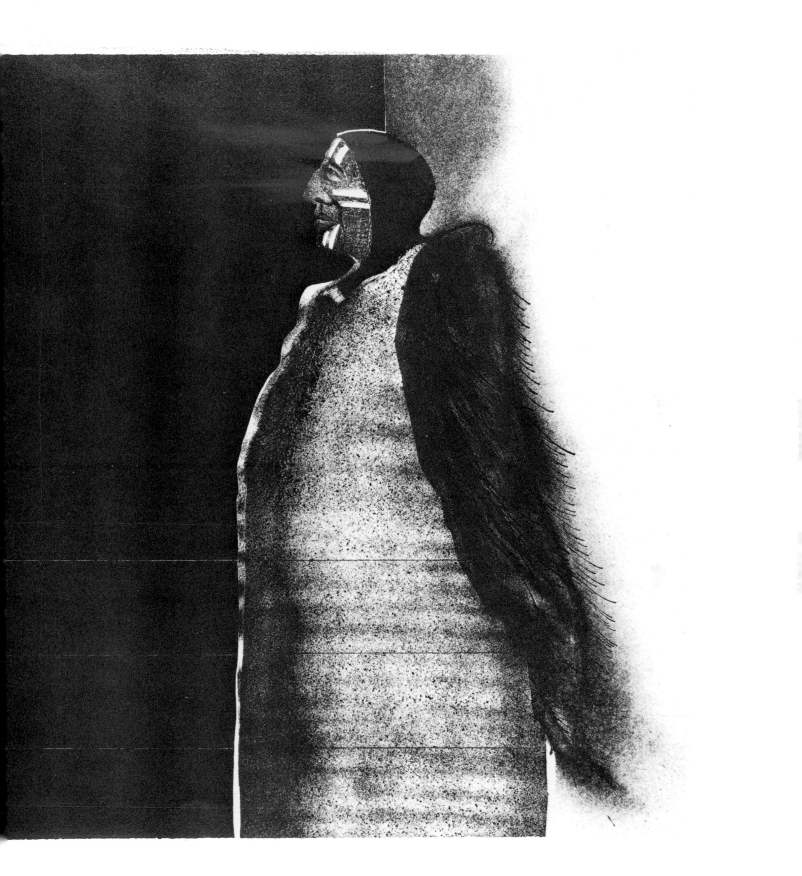

BIRD INDIAN

February 1973 [Editions Press 288], four color
22 × 30 (55.9 × 76.2), German etching paper
Edition: 100 plus BAT, 2PrP II, TP, EPAP, 15AP, 5PP
Printed by Ernest F. DeSoto

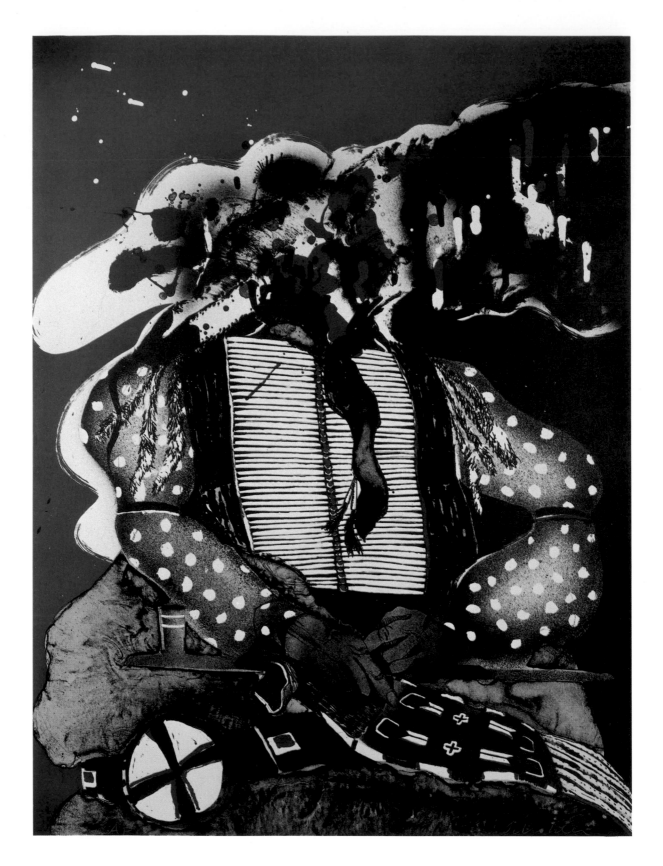

PORTRAIT OF A MASSACRED INDIAN NO. 3

February 1973 [Editions Press 289], four color
40 × 30 (101.6 × 76.2), Rives BFK
Edition: 100 plus BAT, PrP II, EPAP, 15AP, 4PP, CP
Printed by Lloyd Baggs

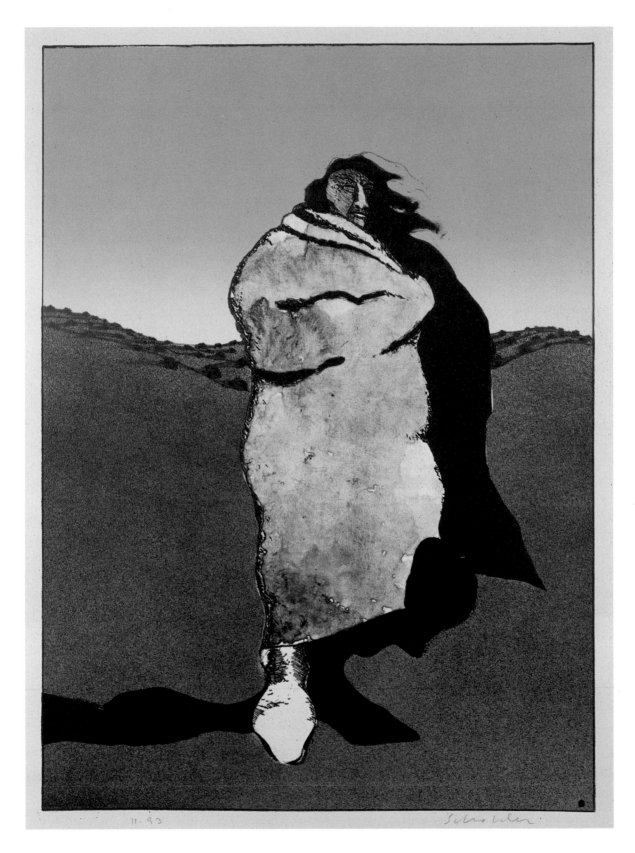

SANTA FE INDIAN

June 1973 [73-681], four color
30 × 22 (76.2 × 55.9), buff Arches
Edition: 93 plus BAT, 3TP, 4CTP, 2T, CP
Printed by Harry Westlund

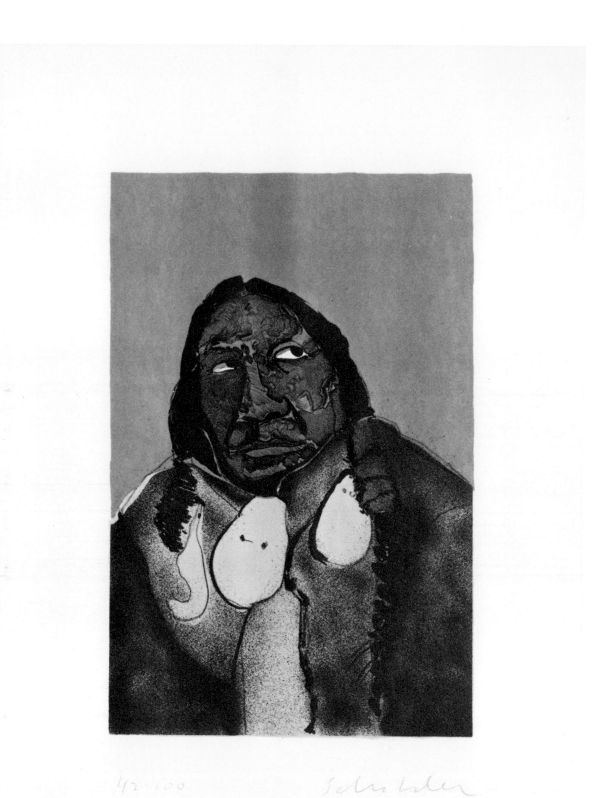

INDIAN PORTRAIT NO. 2 (First State)

July 1973 [73-690], three color
15⅛ × 11½ (38.5 × 29.2), buff Arches
Edition: 100 plus BAT, 3TP, 6CTP, 10AP, 2T
Printed by Ben Q. Adams

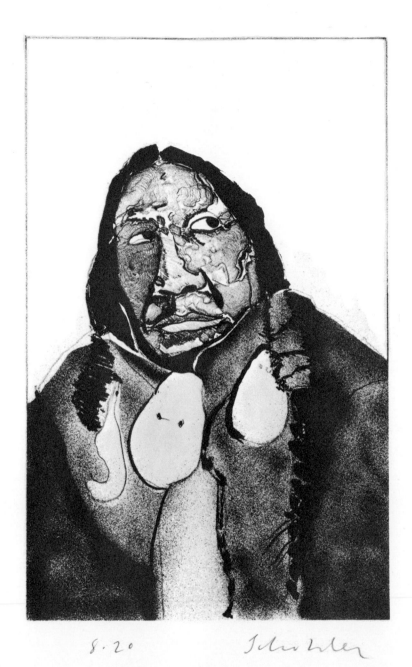

g. 20 Scholder

INDIAN PORTRAIT NO. 2 (Second State)

July 1973 [73-248], one color
15⅛ × 11½ (38.5 × 29.2), buff Arches
Edition: 20 plus BAT, 3TP, 2AP, 2T, 7R, CP
Printed by Ben Q. Adams

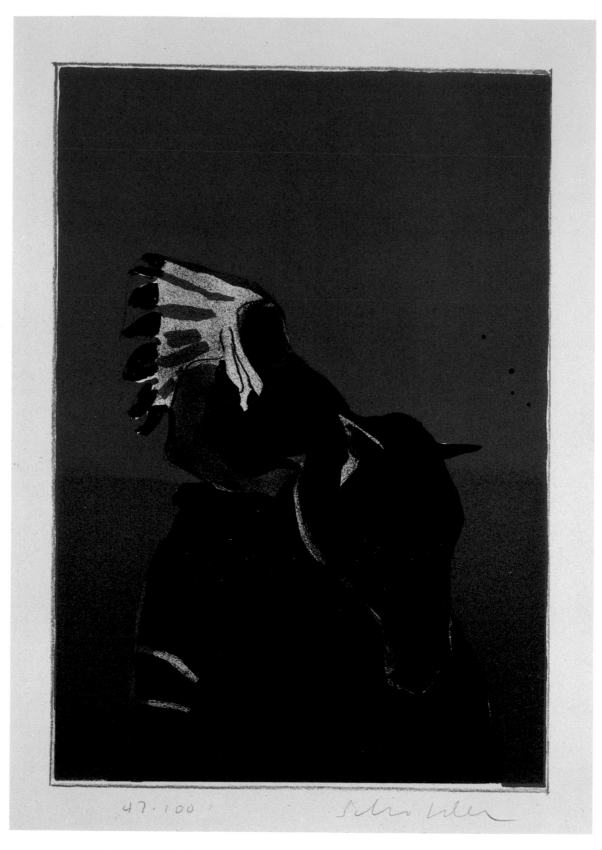

47.100 Schröder

INDIAN ON HORSE NO. 3 (First State)

July 1973 [73-691], three color
15 × 11 (38.1 × 27.9), buff Arches
Edition: 100 plus BAT, 3TP, 6CTP, 10AP, 2T
94 Printed by Ben Q. Adams

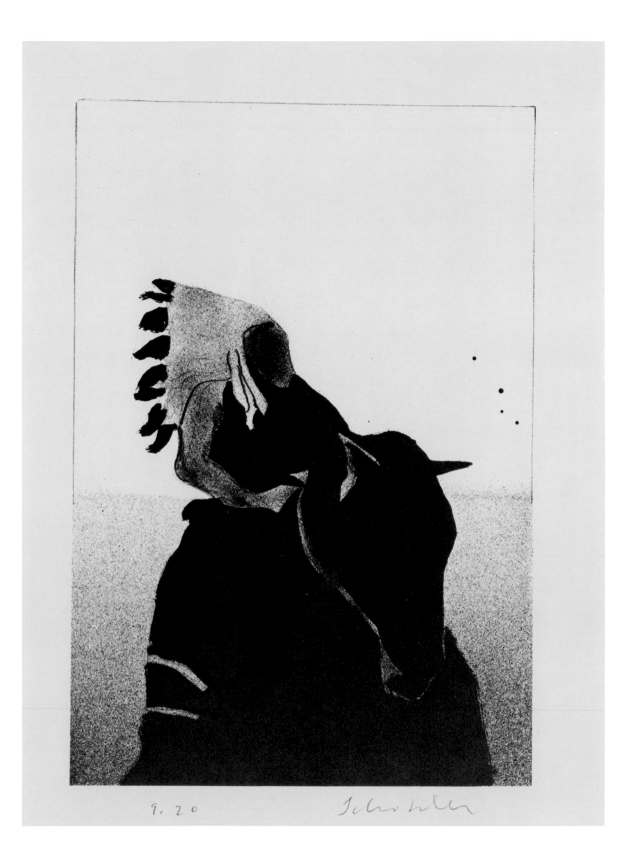

9.20 Scholder

INDIAN ON HORSE NO. 3 (Second State)

July 1973 [73-249], one color
15 × 11 (38.1 × 27.9), buff Arches
Edition: 20 plus BAT, 3TP, 2AP, 2T, 7R, CP
Printed by Ben Q. Adams

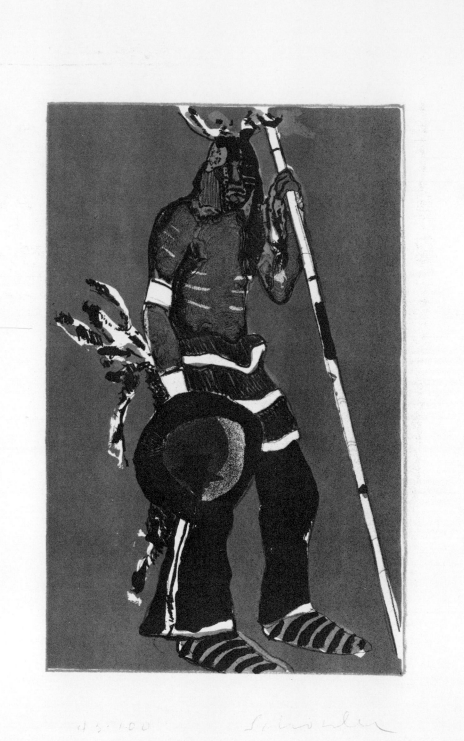

INDIAN WITH SHIELD (First State)

July 1973 [73-693], three color
15 × 11 (38.1 × 27.9), buff Arches
Edition: 100 plus BAT, 3TP, 6CTP, 10AP, 2T
Printed by Ben Q. Adams

96

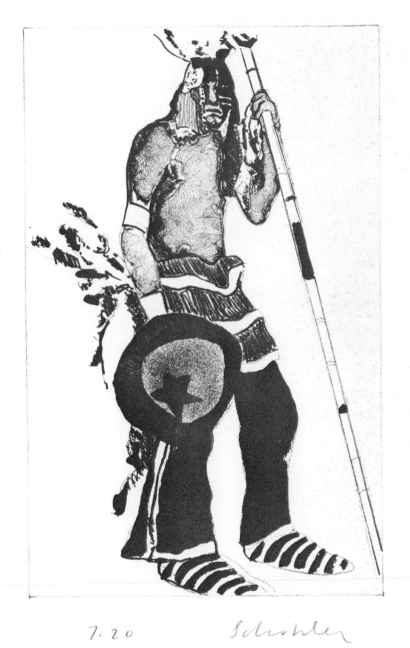

7.20 Scholder

INDIAN WITH SHIELD (Second State)

July 1973 [73-251], one color
15 × 11 (38.1 × 27.9), buff Arches
Edition: 20 plus BAT, 3TP, 2T, 7R, CP
Printed by Ben Q. Adams

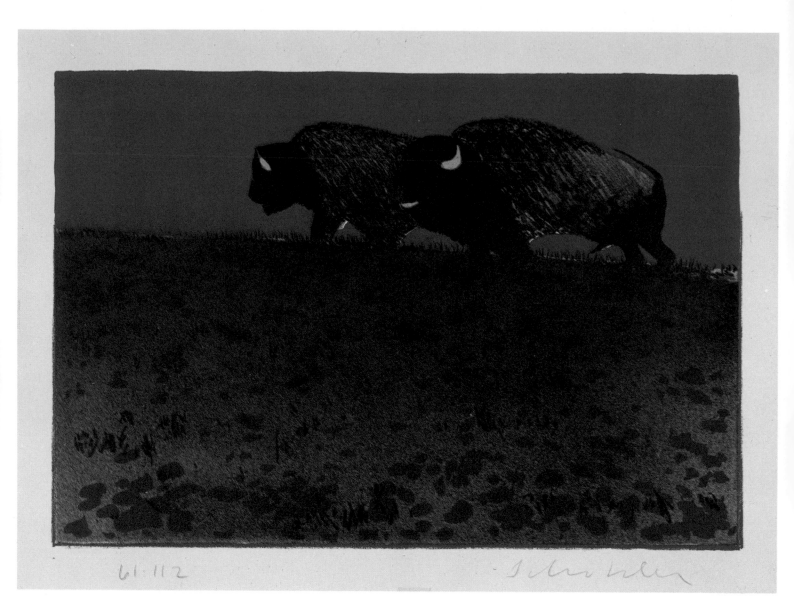

61·112 *[signature]*

BUFFALO AND MATE (First State)

July 1973 [73-692], three color
11¼ × 15 (28.6 × 38.1), buff Arches
Edition: 112 plus BAT, 3TP, 6CTP, 10AP, 2T

Printed by Ben Q. Adams

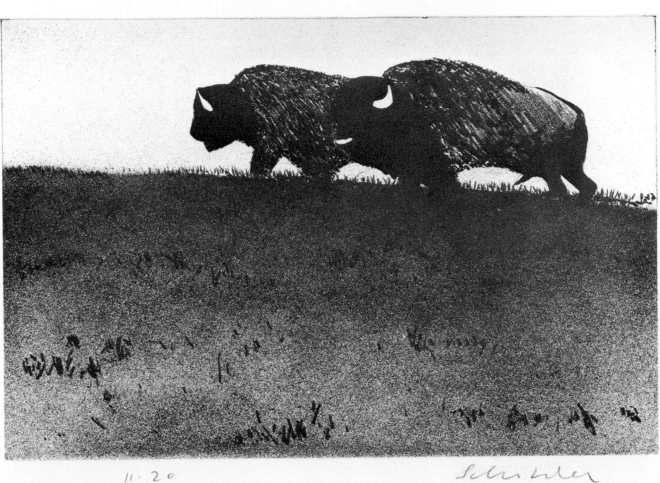

11·20 Schneider

BUFFALO AND MATE (Second State)

July 1973 [73-250], one color
11¼ × 15 (28.6 × 38.1), buff Arches
Edition: 20 plus BAT, 3TP, AP, 2T, 7R, CP
Printed by Ben Q. Adams

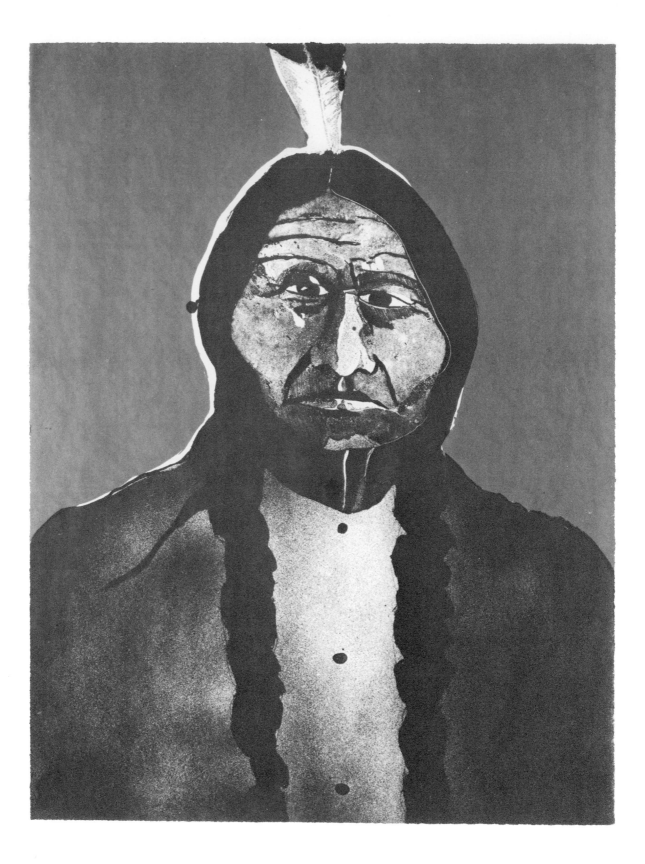

PORTRAIT OF AN AMERICAN NO. 2 (First State)

August 1973 [73-239a], two color
30 × 22 (76.2 × 55.9), white Arches
Edition: 57 plus BAT, TP, 2CTP, 5AP, 2T, 7R, CP
Printed by Ben Q. Adams

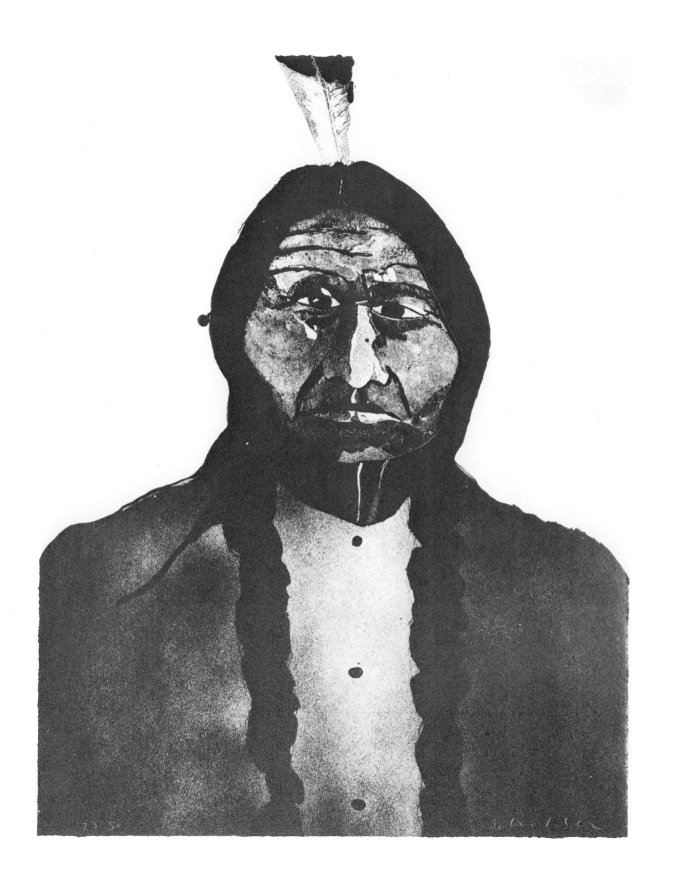

PORTRAIT OF AN AMERICAN NO. 2 (Second State)

August 1973 [73-239], one color
30 × 22 (76.2 × 55.9), buff Arches
Edition: 50 plus BAT, TP, 5AP, 2T, 7R
Printed by Ben Q. Adams

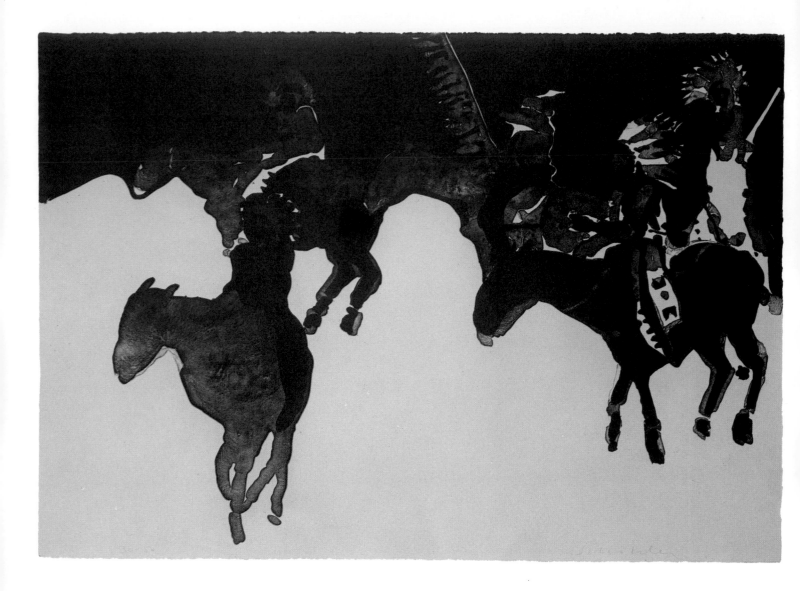

DAKOTA WINTER NIGHT NO. 2 (First State)

August 1973 [73-704], two color
22¼ × 30 (56.5 × 76.2), Copperplate Deluxe
Edition: 50 plus BAT, 3TP, 5CTP, 5AP, 2T
Printed by Harry Westlund

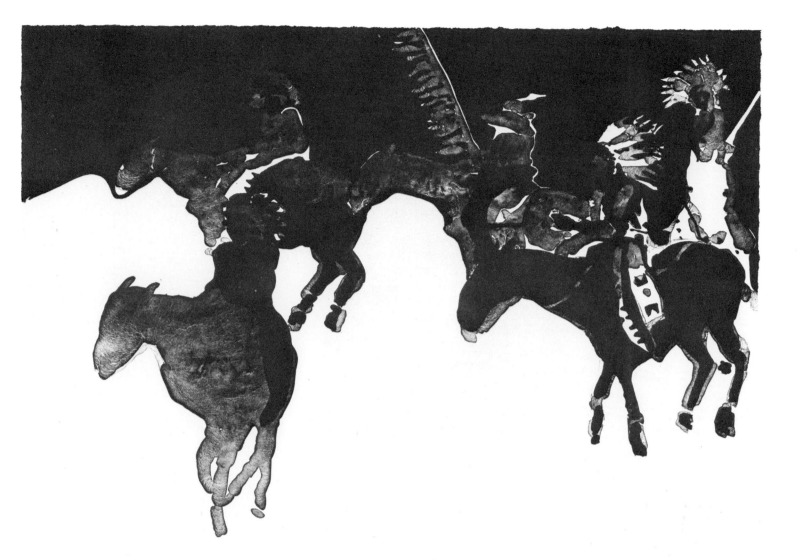

DAKOTA WINTER NIGHT NO. 2 (Second State)

August 1973 [73-238], one color
22 × 30 (55.5 × 76.2), buff Arches
Edition: 50 plus BAT, 2TP, 5AP, 2T, 7R, CP
Printed by Harry Westlund

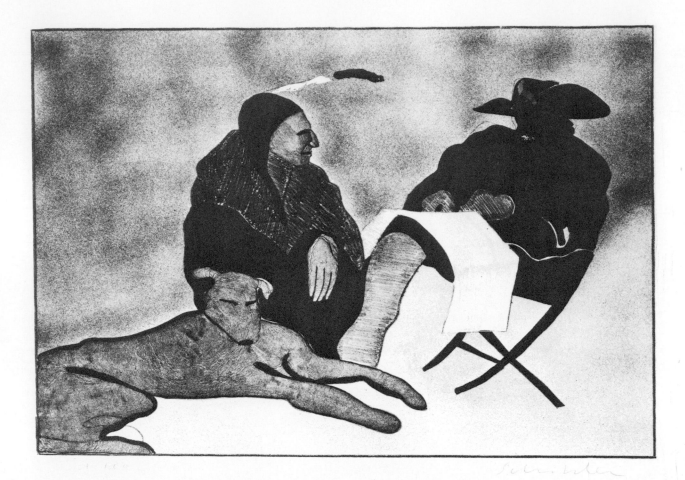

INDIAN, DOG AND FRIEND

August 1973 [73-230], one color
17 × 23 (43.2 × 58.4), buff Arches
Edition: 100 plus BAT, 4TP, 10AP, 2T, 7R, CP
Printed by Richard Newlin

1974

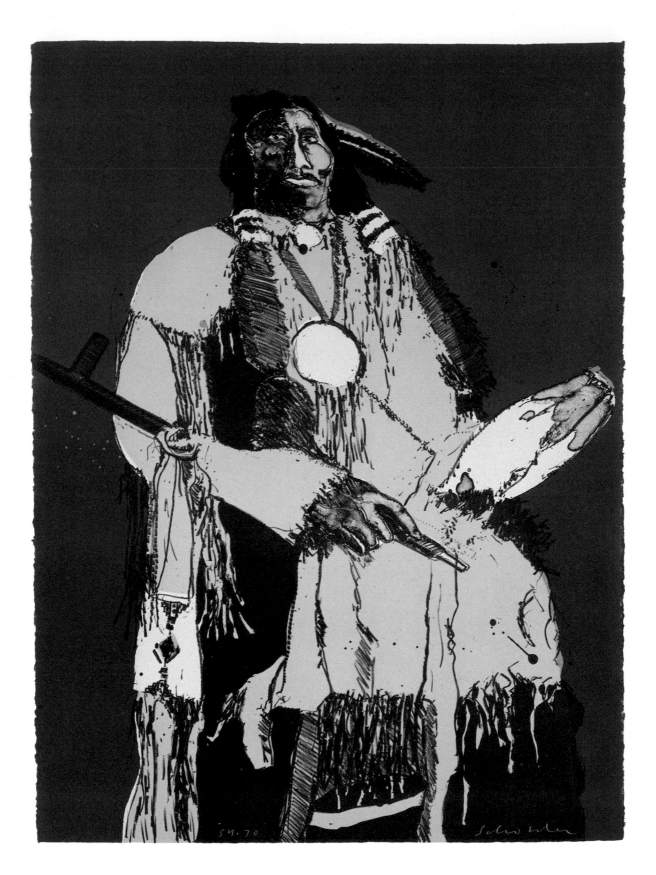

BUCKSKIN INDIAN (First State)

May 1974 [74-635a], three color
30 × 22 (76.2 × 55.9), buff Arches
Edition: 75 plus BAT, 2TP, CTP, AP, 2T
Printed by Harry Westlund

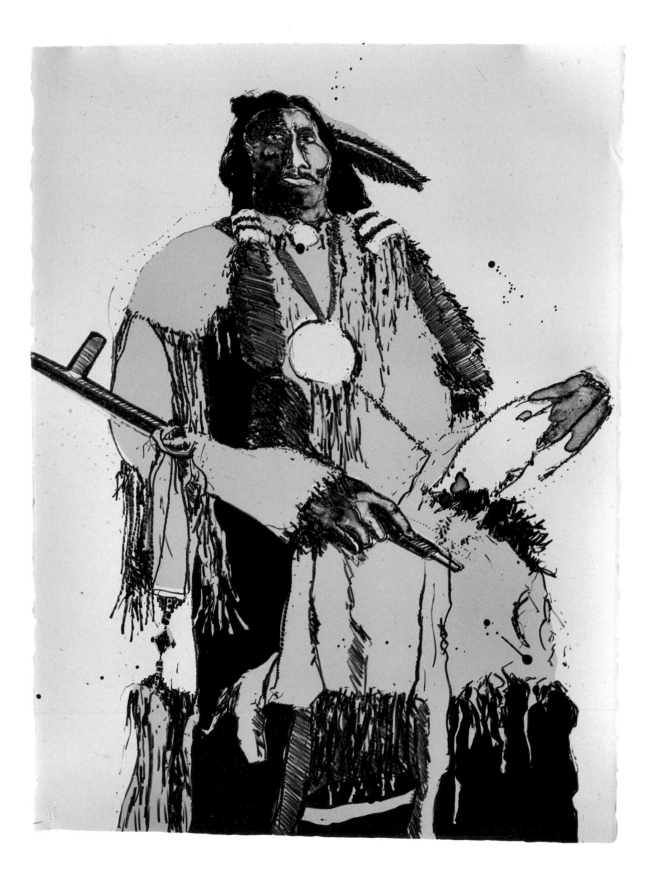

BUCKSKIN INDIAN (Second State)

May 1974 [74-635], two color
30 × 22 (76.2 × 55.9), buff Arches
Edition: 75 plus BAT, 2TP, 5AP, 2T
Printed by Harry Westlund

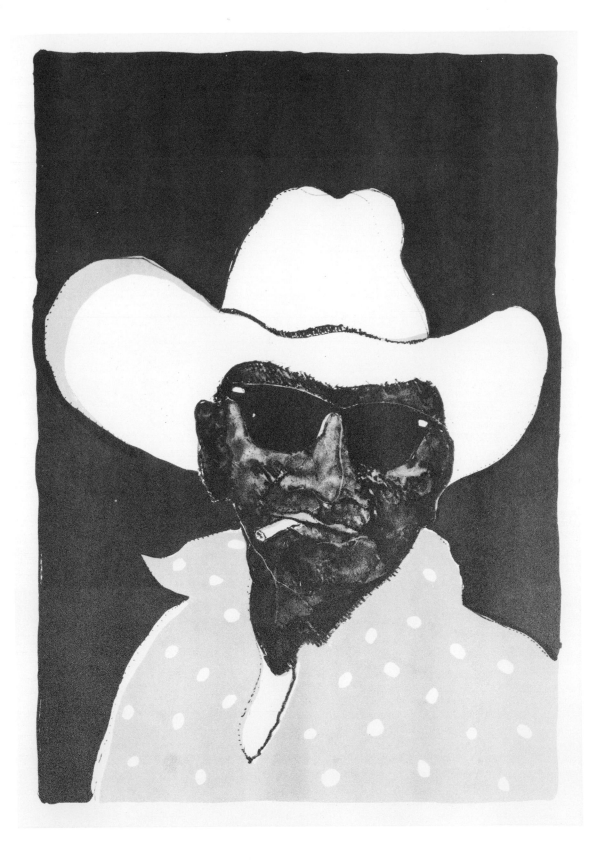

COWBOY INDIAN (First State)

May 1974 [74-636], two color
24 × 17 (58.4 × 43.2), Rives BFK
Edition: 100 plus BAT, TP, 8CTP, 8AP, 2T
Printed by Ben Q. Adams

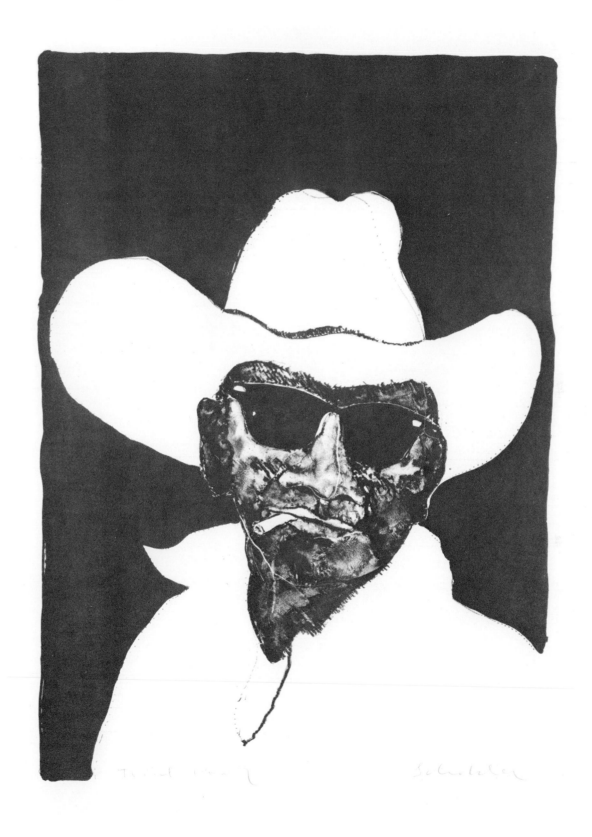

COWBOY INDIAN (Second State)

May 1974 [74-178], one color
24 × 17 (58.4 × 43.2), white Arches
Edition: 20 plus BAT, 5TP, 2AP, 2T, 7R
Printed by Ben Q. Adams

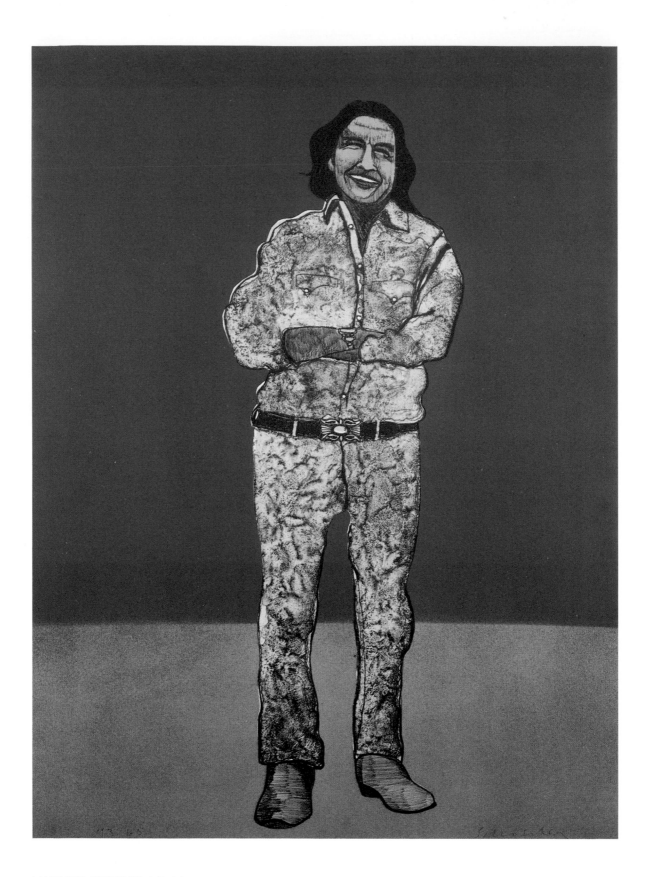

LAUGHING ARTIST (First State)

May 1974 [74-638], four color
30 × 22 (76.2 × 55.9), white Arches
Edition: 65 plus BAT, TP, 2CTP, 2T
Printed by Harry Westlund

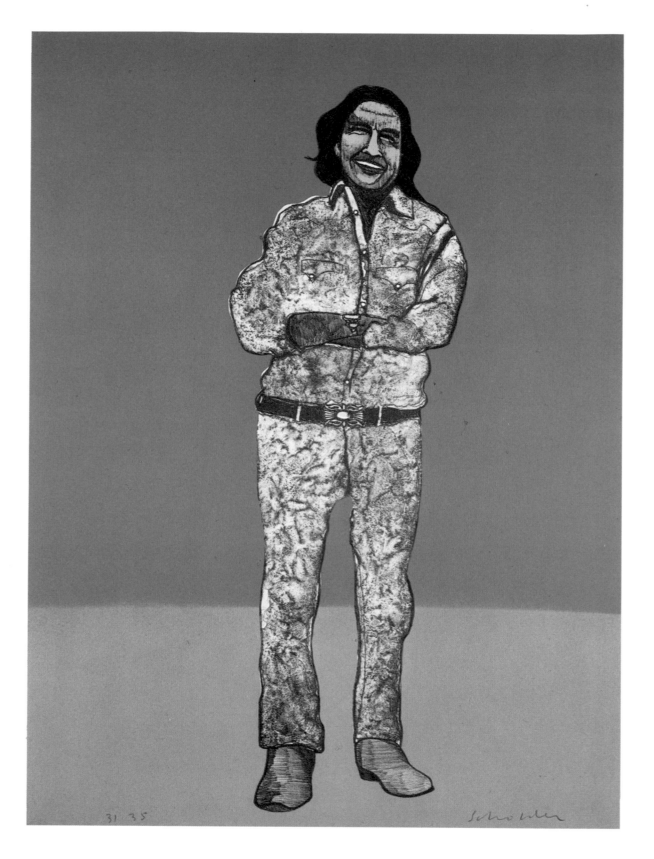

31 35 Schonder

LAUGHING ARTIST (Second State)

May 1974 [74-638a], four color
30 × 22 (76.2 × 55.9), Rives BFK
Edition: 35 plus BAT, 2CTP, 2T
Printed by Harry Westlund

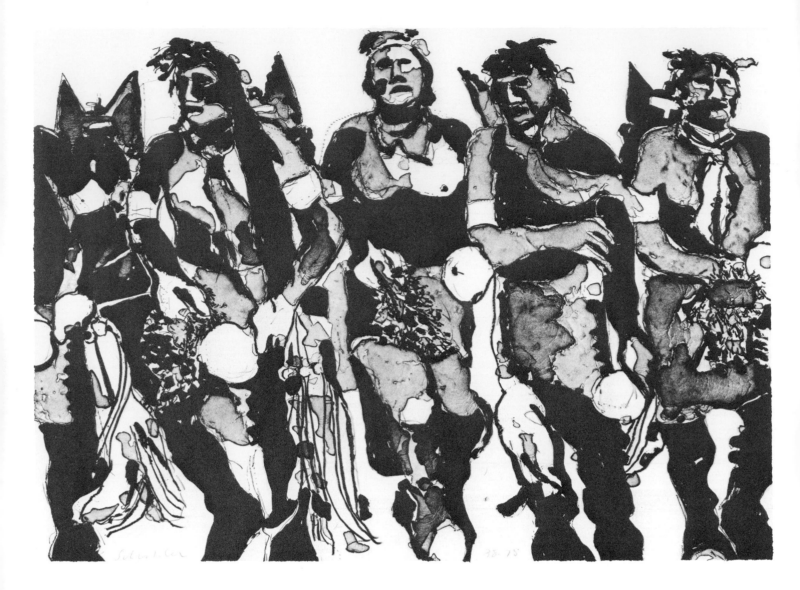

HOPI DANCERS (Second State)

May 1974 [74-637], one color
22 × 30 (55.9 × 76.2), buff Arches
Edition: 75 plus BAT, 4TP, 7AP, 2T
Printed by Ben Q. Adams

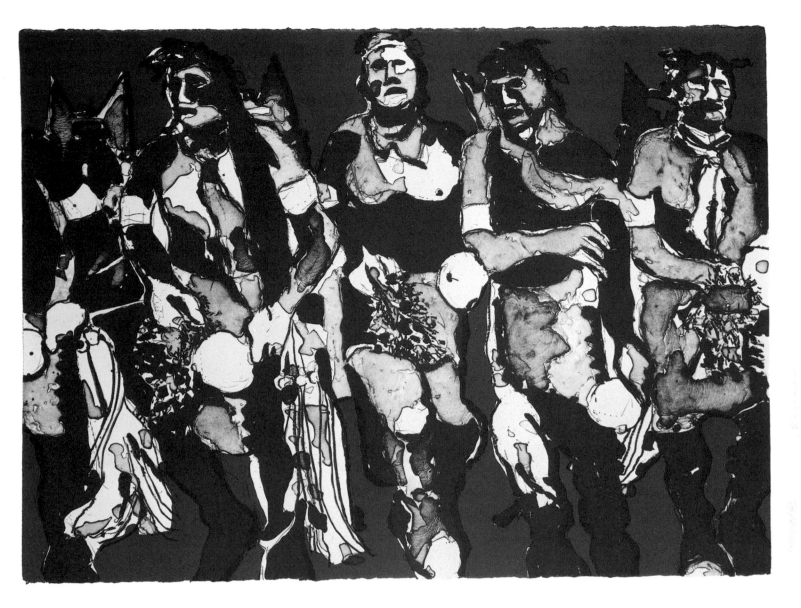

HOPI DANCERS (First State)

May 1974 [74-637a], two color
22 × 30 (55.9 × 76.2), buff Arches
Edition: 75 plus BAT, 3TP, 8AP, 2T
Printed by Ben Q. Adams

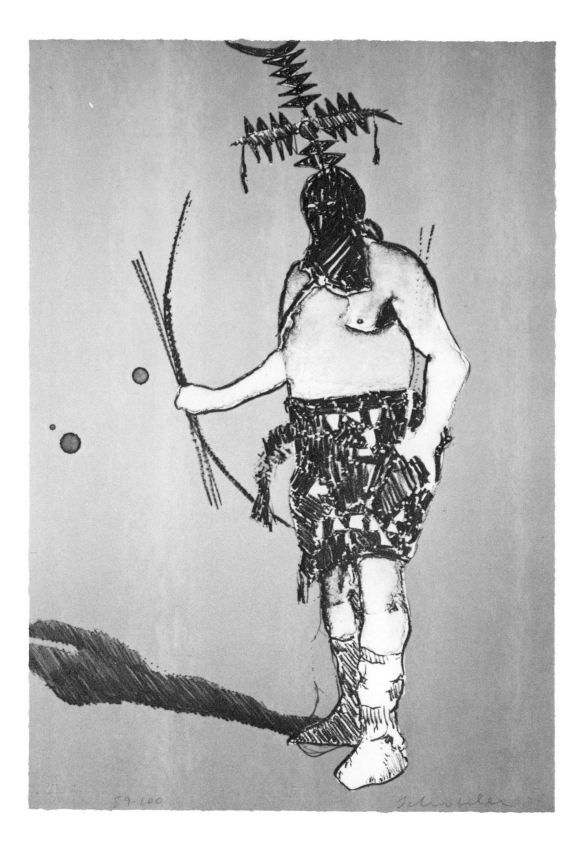

APACHE NIGHT DANCER (First State)

May 1974 [74-634], three color
22 × 15 (55.9 × 38.1), buff Arches
Edition: 100 plus BAT, 3TP, 10AP, 2T
Printed by Stephen Britko

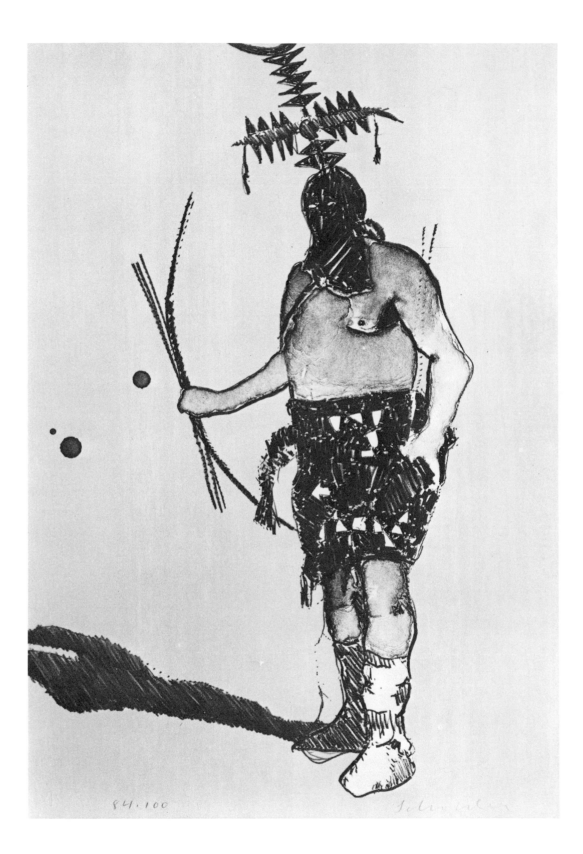

84.100

APACHE NIGHT DANCER (Second State)

May 1974 [74-181], one color
22 × 15 (55.9 × 38.1), buff Arches
Edition: 20 plus BAT, 2TP, AP, 2T, 7R
Printed by Stephen Britko

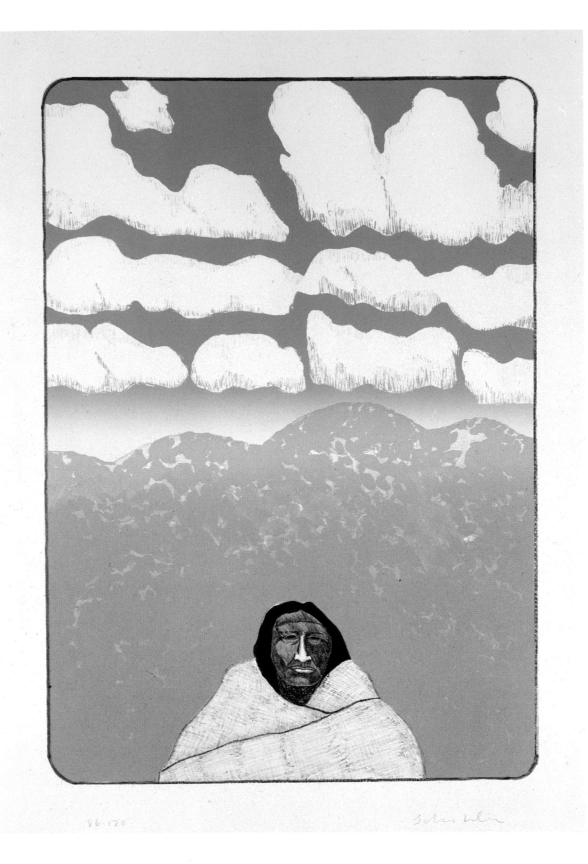

NEW MEXICO (First State)

September 1974 [74-702], five color
30 × 22 (76.2 × 55.9), buff Arches
Edition: 120 plus BAT, 3TP, 5AP, 2T
Printed by Jim Reed

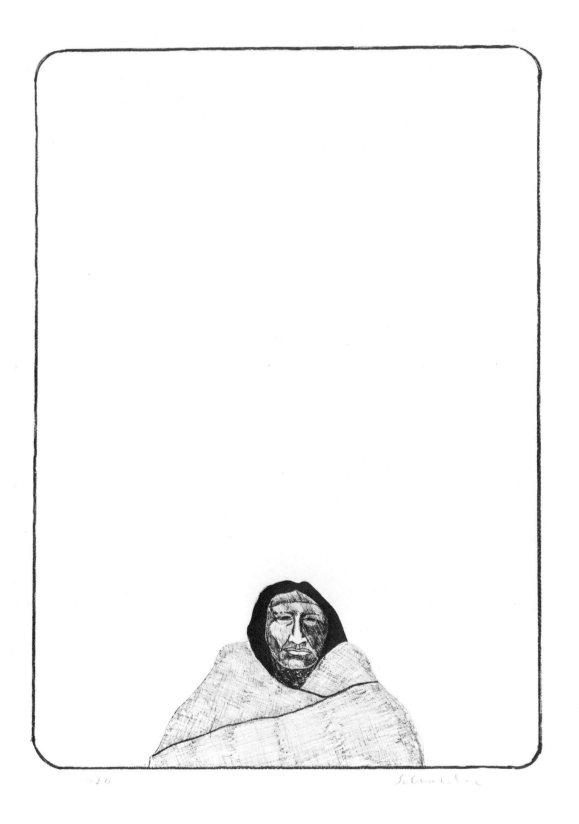

NEW MEXICO (Second State)

September 1974 [74-246], one color
30 × 22 (76.2 × 55.9), buff Arches
Edition: 20 plus BAT, 2TP, 2AP, 2T, 7R
Printed by Jim Reed

FEATHER FAN (First State)

May 1974 [74-639], one color
14 × 10 (35.6 × 25.4), buff Arches
Edition: 50 plus BAT, TP, 4AP, 2T
Printed by Ben Q. Adams

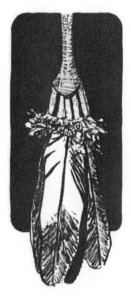

11.50 *(signature)*

FEATHER FAN (Second State)

May 1974 [74-639a], one color
14 × 10 (35.6 × 25.4), buff Arches
Edition: 50 plus BAT, 5AP, 2T
Printed by Ben Q. Adams

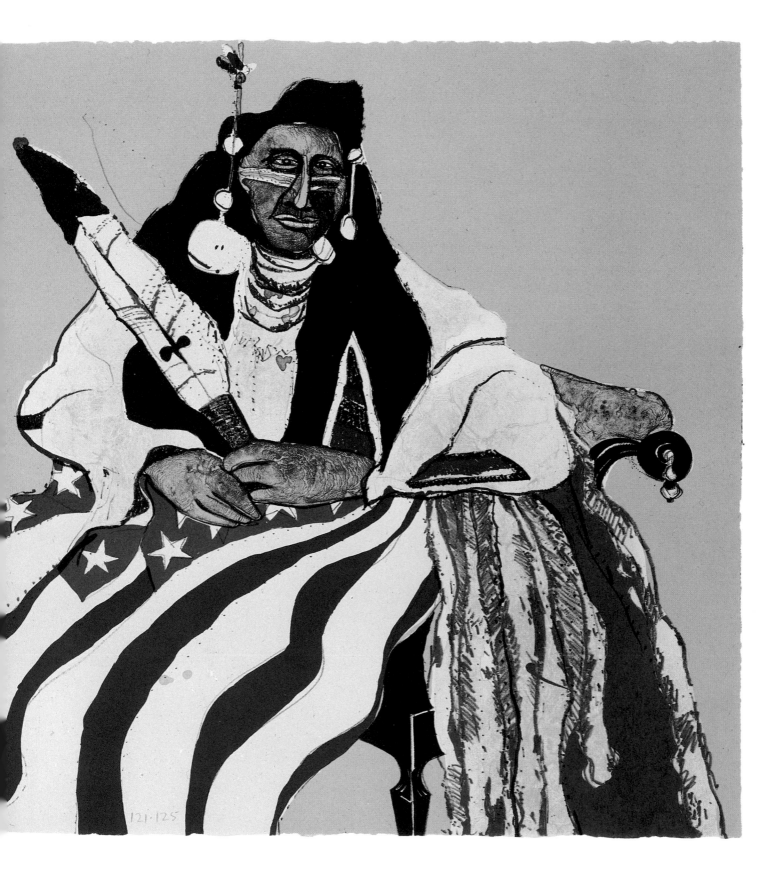

BICENTENNIAL INDIAN

September 1974 [74-701], four color
22 × 30 (55.9 × 76.2), Rives BFK
Edition: 125 plus BAT, 4TP, 2CTP, 13AP, 2T, CP
Printed by Harry Westlund

31.50 Schneider

NIGHT PUEBLO (First State)

May 1974 [74-640], one color (blue)
14 × 10 (35.6 × 25.4), buff Arches
Edition: 50 plus BAT, TP, 5AP, 2T
122 Printed by Ben Q. Adams

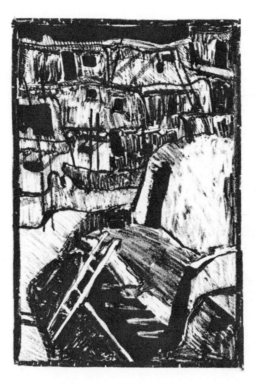

36.50 Schidler

NIGHT PUEBLO (Second State)

May 1974 [74-640a], one color (brown)
14 × 10 (35.6 × 25.4), buff Arches
Edition: 50 plus BAT, TP, 5AP, 2T
Printed by Ben Q. Adams

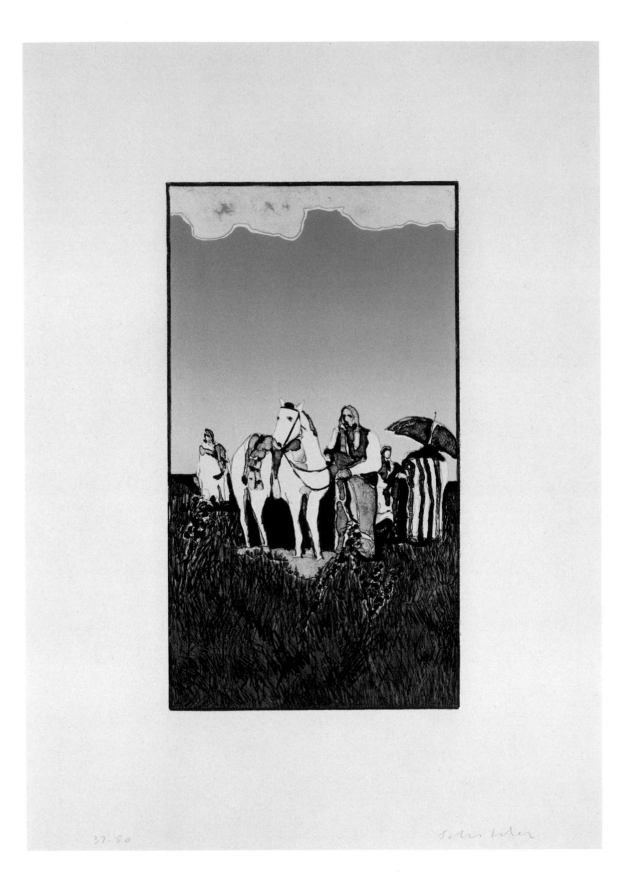

INDIAN LANDSCAPE (Second State)

September 1974 [74-704a], six color
28 × 20 (71.1 × 50.8), white Arches
Edition: 50 plus BAT, 3TP, 4CTP, 5AP, 2T

Printed by Ben Q. Adams

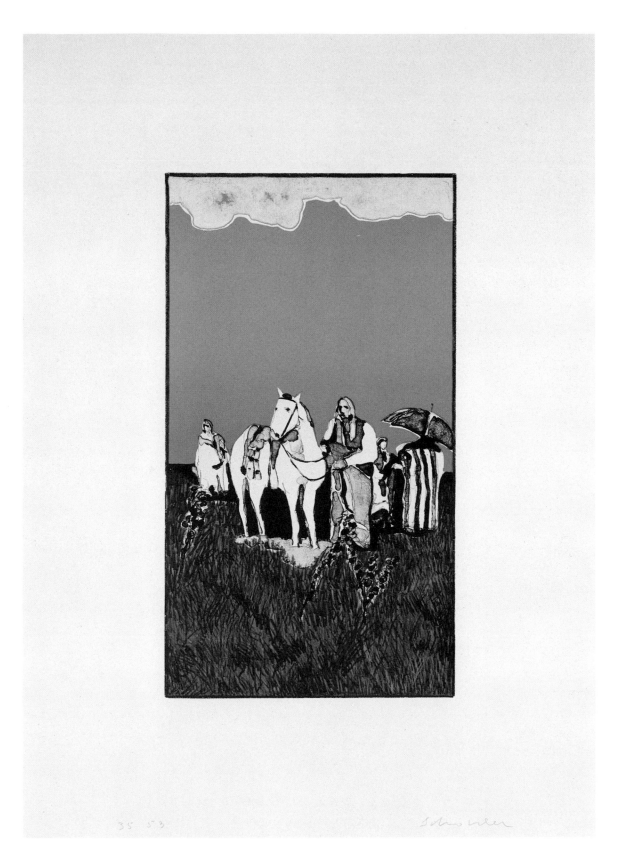

INDIAN LANDSCAPE (Third State)

September 1974 [74-704b], three color
28 × 20 (71.1 × 50.8), white Arches
Edition: 53 plus BAT, TP, 5AP, 2T
Printed by Ben Q. Adams

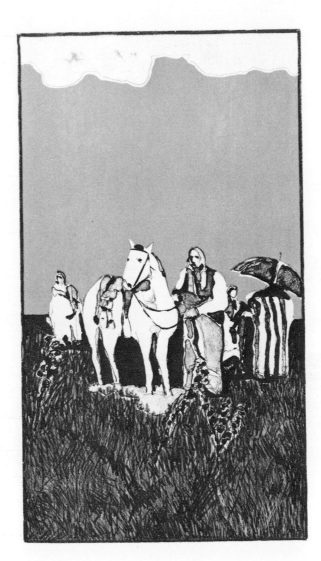

INDIAN LANDSCAPE (First State)

September 1974 [74-704], two color
28 × 20 (71.1 × 50.8), buff Arches
Edition: 50 plus BAT, 2TP, 7CTP, 5AP, 2T

Printed by Ben Q. Adams

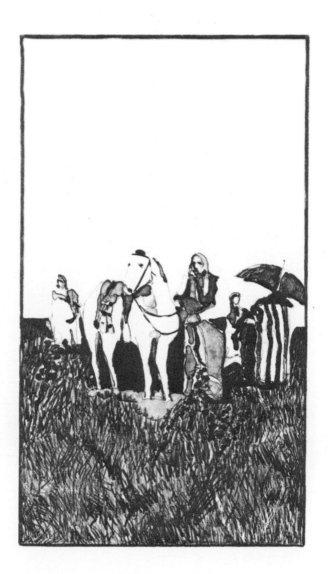

INDIAN LANDSCAPE (Fourth State)

September 1974 [74-704c], one color
28 × 20 (71.1 × 50.8), buff Arches
Edition: 27 plus BAT, TP, 3AP, 2T
Printed by Ben Q. Adams

VAMPIR

September 1974 [74-703], two color
8 × 6 (20.3 × 15.2), buff Arches
Edition: 50 plus BAT, 6TP, 5AP, 2T
Printed by Stephen Britko

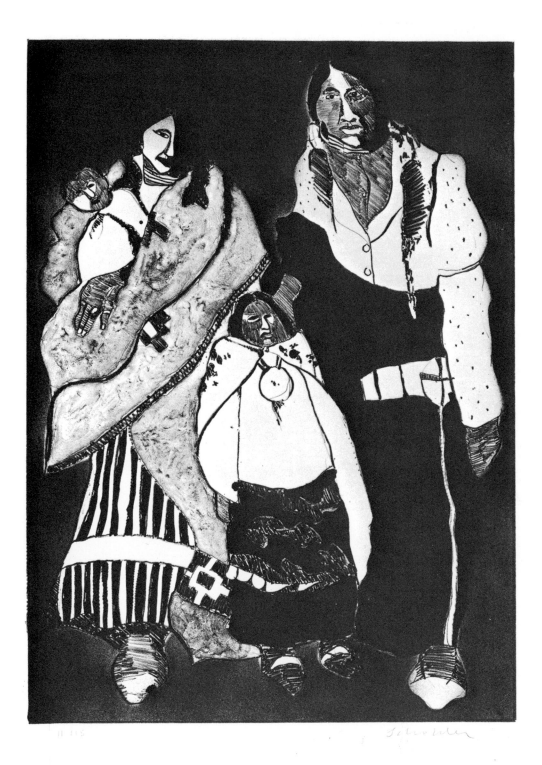

AMERICAN FAMILY

December 1974 [74-728], one color
30 × 22 (76.2 × 55.9), buff Arches
Edition: 115 plus BAT, 4TP, CTP, 7AP, 2T
Printed by Harry Westlund

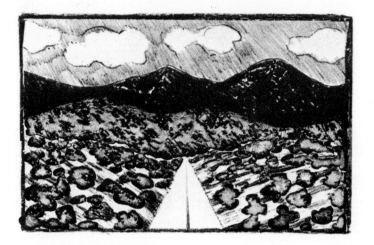

TO SANTA FE FROM GALISTEO NO. 2 (First State)

May 1974 [74-641], one color
10 × 14 (25.4 × 35.6), buff Arches
Edition: 50 plus BAT, 2TP, 5AP, 2T
Printed by Ben Q. Adams

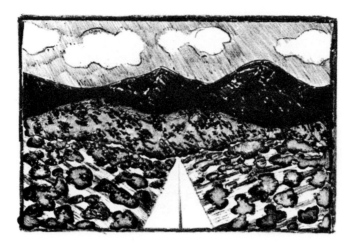

13.50 Schölder

TO SANTA FE FROM GALISTEO NO. 2 (Second State)
May 1974 [74-641a], one color
10 × 14 (25.4 × 35.6), buff Arches
Edition: 50 plus BAT, TP, 5AP, 2T
Printed by Ben Q. Adams

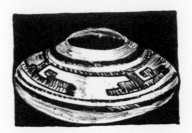

35.50 Schmidt

HOPI POT (First State)

May 1974 [74-642], one color
10 × 14 (25.4 × 35.6), buff Arches
Edition: 50 plus BAT, TP, 5AP, 2T
Printed by Ben Q. Adams

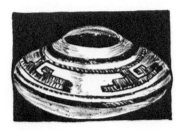

12.50 Schindler

HOPI POT (Second State)

May 1974 [74-642a], one color
10 × 14 (25.4 × 35.6), buff Arches
Edition: 50 plus BAT, TP, 5AP, 2T
Printed by Ben Q. Adams

133

1975

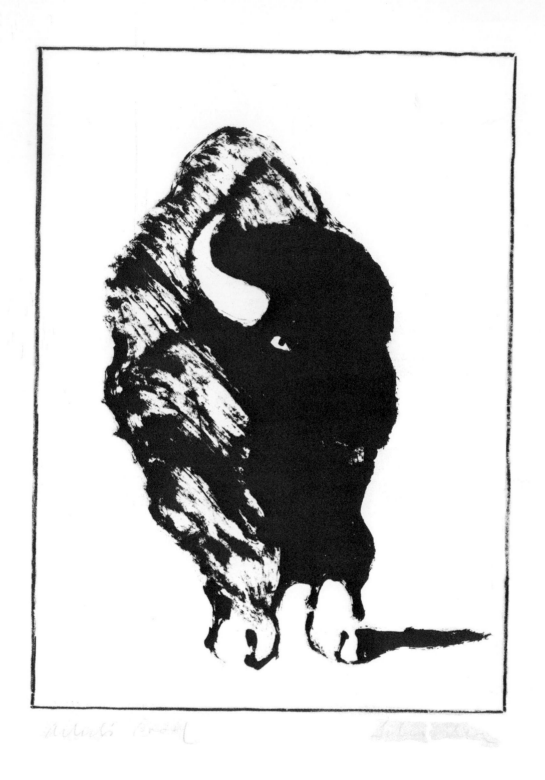

THE BUFFALO

February 1975 [75-606], one color
20 × 15 (50.8 × 31.1), buff Arches
Edition: 100 plus BAT, 2TP, 10AP, 2T
Printed by Ben Q. Adams

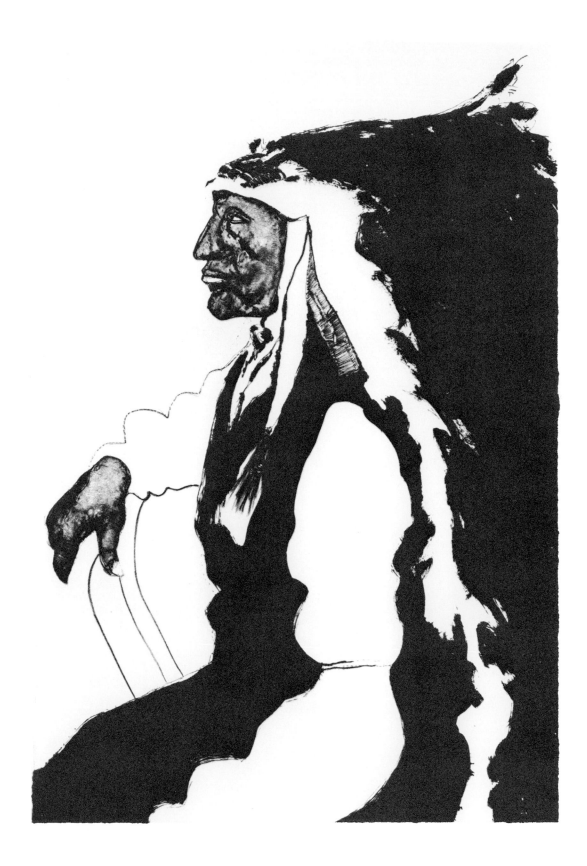

PATRIOTIC INDIAN (Third State)

February 1975 [75-610a], one color
22 × 15 (55.9 × 38.1), buff Arches
Edition: 50 plus BAT, 5AP, 2T
Printed by Stephen Britko

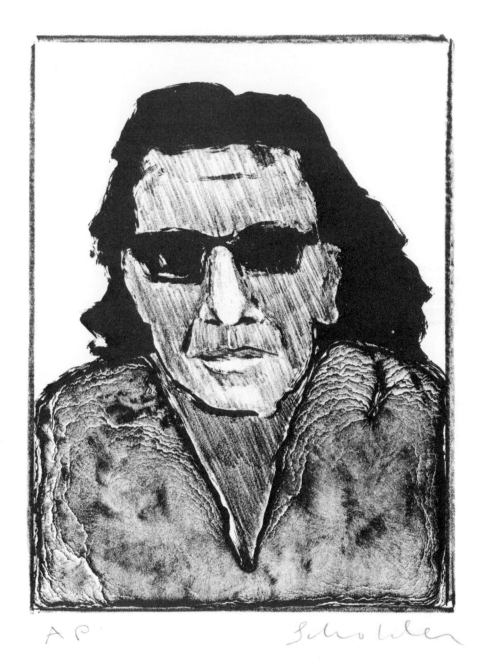

AP Scholder

SELF-PORTRAIT WITH DARK GLASSES (Second State)

February 1975 [75-124], one color
11 × 9 (28.0 × 22.9), buff Arches
Edition: 20 plus BAT, 2TP, 2AP, 2T, 7R
Printed by Harry Westlund

artist's proof *Schindler*

NOBLE INDIAN AFTER DIXON (First State)

February 1975 [75-608], one color
17 × 17 (43.2 × 43.2), buff Arches
Edition: 50 plus BAT, 4CTP, 5AP, 2T
Printed by Harry Westlund

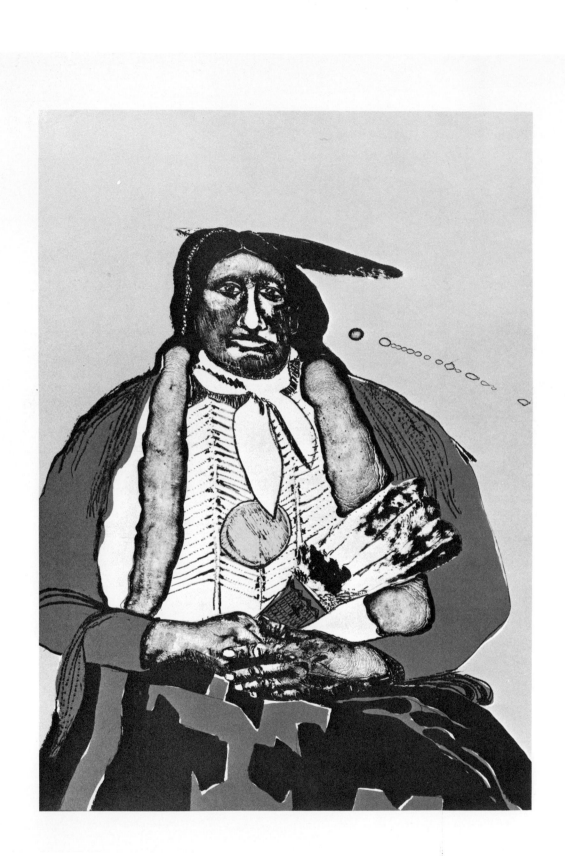

INDIAN WITH FEATHER FAN (Second State)

February 1975 [75-609a], three color
30 × 22 (76.2 × 55.9), German etching paper
Edition: 50 plus BAT, TP, CTP, 4AP, 2T
Printed by Ben Q. Adams

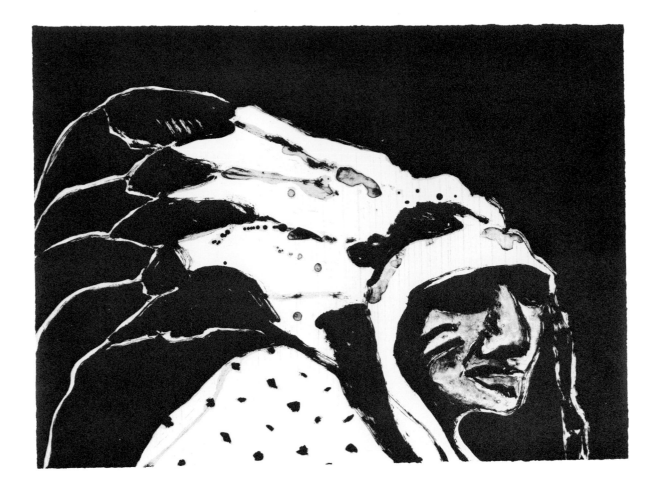

FILM INDIAN

April 1975 [75-136], one color
21 × 29 (53.3 × 73.7), buff Arches
Edition: 160 plus BAT, PrP, 3TP, 15AP, 2T, 7R
Printed by Harry Westlund, assisted by Frances Thiel

Documentation

Chronology

1937
Born October 6 in Breckenridge, Minnesota, the son of Fritz William Scholder IV, of German, California Mission Indian (Luiseño), and French descent, and Ella Mae Haney, of English-Irish descent. His father was an administrator of the local Indian school and had his career in the Bureau of Indian Affairs. Has two sisters, Sondra and Kristina, both musicians.

1946
Wins poster contest in fourth grade. Always identified as an artist.

1950–54
Family moves to Pierre, South Dakota. Studies art in high school with Oscar Howe, noted Sioux painter. Introduced to modern painting.

1955–57
Family moves to Wisconsin. Wins scholarship to the Mid-West Music and Art Camp, University of Kansas. Elected president of art camp; selected "Outstanding Boy Artist." Studies art at Wisconsin State College, Superior.

1957–58
Family moves to Sacramento, California. Studies painting and art history with Wayne Thiebaud at Sacramento City College.

1958
Thiebaud gives him first one-man show at the Sacramento City College Art Gallery. Sells first major painting. Marries Peggy Stephenson. Is Arts and Crafts Instructor at the Sacramento YMCA. One-man show at the Artists' Cooperative Gallery, Sacramento.

1959
One-man show at the E. B. Crocker Art Gallery, Sacramento. Works with lithography for the first time.

1960
Son, Fritz VI, born. Bachelor of Arts degree from Sacramento State College.

1960–61
Substitute teacher in Sacramento City Schools; works nights at California State Motor Vehicle Department. Spends a good part of the time picking up discarded burlap and wood for stretchers for painting materials. First professional award: First Prize, 10th Southwestern Painters' Festival Show, Tucson Art Center. First Prize in oils several months later at the First California Spring Festival Exhibition, Sacramento.

1961–62
Full scholarship to participate in the Southwest Indian Art Project under the auspices of the Rockefeller Foundation. First time that he identifies as being part Indian. Faculty member of Southwest Indian Art Project in the second summer session.

1962
Ford Foundation Purchase Award in competition, The Southwest: Painting and Sculpture, at the Houston Museum of Fine Arts. The jurors are James Johnson Sweeney, Alexander Calder, and James Brooks. John Hay Whitney Opportunity Fellowship. Moves to Tucson to work for a Master of Fine Arts degree at the University of Arizona. Teaches design and drawing as a graduate assistant.

1963
First Prize for a Painting by an American Artist at the West Virginia Centennial Painting Exhibition. The juror is James Johnson Sweeney. Edwin B. Hopkins Purchase Award in Drawing, 13th Southwestern Drawing and Print Exhibition, Dallas Museum of Fine Arts.

1964
Master's Exhibition at the University of Arizona Art Gallery. Receives Master of Fine Arts degree. Begins to teach advanced painting and art history at the new Institute of American Indian Arts in Santa Fe, New Mexico. Starts New Mexico series of paintings. Bureau of Indian Affairs buys first work, a small collage. During the following five years the Bureau buys many major paintings.

1965
Divorces Peggy Stephenson. Hallmark Purchase Award, 10th Mid-America Exhibition, Nelson Gallery, Kansas City. Represented in group exhibition which tours Europe and South America, sponsored by the Department of the Interior.

1966
Marries Romona Attenberger in Tesuque, New Mexico. First Prize in Experimental Work, Scottsdale National Indian Art Exhibition. Ends New Mexico series. Starts and ends the Butterfly series of paintings.

1967
Starts the Indian series of paintings. First one-man show in Santa Fe, at the College of Santa Fe. Grand Prize in First Biennial Exhibition of American Indian Arts and Crafts, Center for Arts of Indian America, Washington, D.C.

1968
Special Award, Polymer Painting, Scottsdale National Indian Art Exhibition. Juror for the National Indian Painting and Sculpture Annual, Philbrook Art Museum. Tours Indian schools in California, Oklahoma, Utah, South Dakota, Kansas, and Alaska. One of the "Three From Santa Fe" Exhibition at the Center for Arts of Indian America, sponsored by the Department of the Interior and hosted by Secretary and Mrs. Stewart Udall. Exhibit receives national publicity. Exhibits in New York for the first time, at the Lee Nordness Galleries.

1969
Resigns from the Institute of American Indian Arts. Three major prizes at the Scottsdale National Indian Art Exhibition — Grand Prize, Special Award for Oil Painting, and Special Award for Polymer Painting. Tours Europe and Northern Africa for the first time with Romona. Spends three months in Tunisia, Italy, Spain, France, Switzerland, Germany, Belgium, Holland, and England. Sees Bacon's paintings at the Tate. *Motorcycle Indian* and *New Mexico No. 4* selected for the Museum of Modern Art Lending Service in New York. Returns to Santa Fe, buys an old adobe home with studio, and starts painting full time.

1970
First one-man show in New York. Asked to give paper on the "New Indian Art" at the First Convocation of American Indian Scholars at Princeton University. Sent by the government to "paint the land and water." Tours Navajo reservation and Lake Powell. Invited by Tamarind Institute to do first major work at their new Southwest location. This results in the suite *Indians Forever,* and is the beginning of his work in lithography. Jurors Award, Southwest Fine Arts Biennial, Museum of New Mexico.

1971
One-man show at Heard Museum, Phoenix. Major print show in Santa Fe: "Scholder at Tamarind." Receives Jurors Award, New Mexico Fine Arts Biennial, Museum of New Mexico.

1972
Invited by Adelyn D. Breeskin, Curator, Contemporary Painting and Sculpture of the National Collection of Fine Arts, to have two-man show, "Two American Painters," with his former student, T. C. Cannon, at the Smithsonian Institution, Washington, D.C. *Scholder/Indians,* the first book on the paintings and lithographs, published by Northland Press. Introduction by Breeskin; commentary by Rudy H. Turk, Director, University Art Collections, Arizona State University. With the exhibition "Two American Painters," tours Europe under the auspices of the USIS, State Department, and the Smithsonian, lecturing in Bucharest, Belgrade, London, Berlin, and Paris. Paints a small series of paintings titled "Vampir," after visiting Transylvania. Back to the United States, buys a small house in Scottsdale, Arizona, where he decides to spend winters. Adds studios. Then acquires a large historical adobe hacienda in the village of Galisteo, New Mexico. Is included in PBS television documentary film, "Three Indian Artists."

1973
Exhibits a number of works in a major exhibition, "Indianische Malerei in Nordamerika, 1830–1970," at the Linden Museum in Stuttgart, Germany. Artist-in-Residence for the fall term at Dartmouth College. Two one-man exhibitions at Dartmouth, the second showing an important series-within-a-series, "The Dartmouth Portraits."

1974
Second major one-man show at Cordier & Ekstrom in New York with the "Dartmouth Portraits." Receives critical acclaim. First retrospective exhibition at the Brooks Memorial Art Gallery in Memphis. To Switzerland for Basel V International Art Fair, where he has one-man exhibition. Then visits Egypt and executes a small series of paintings of the pyramids and sphinx on the spot.

1975
Executes his first suite of etchings and aquatints, "Ten Indians," at El Dorado Press in Berkeley, California, and begins work in intaglio prints. Is the subject of a short documentary film, "Scholder the Magician," by Antonio Cores and Toti Bertrand of Spain; also a PBS television documentary, "Fritz Scholder."

Appointments and Awards

Appointments

Faculty member: Southwest Indian Art Project, Rockefeller Foundation, University of Arizona, 1961–1962

Fellow: John Hay Whitney Foundation, 1962–1963

Instructor of Advanced Painting and Art History: Institute of American Indian Arts, Santa Fe, 1964–1969

Artist-in-Residence: Dartmouth College, Hanover, New Hampshire, Fall, 1973

Awards

Tucson Festival Award, 10th Southwestern Painters' Festival Show, 1960

First Prize, 1st California Spring Festival Exhibition, Sacramento, 1961

Ford Foundation Purchase Award, The Southwest: Painting and Sculpture, Houston Museum of Fine Arts, 1962

Edwin B. Hopkins Award in Drawing (Purchase), 13th Southwestern Drawing and Paint Exhibition, Dallas Museum of Fine Arts, 1963

First Prize for Painting by an American Artist, West Virginia Centennial, Huntington, 1963

Hallmark Purchase Award, 10th Mid-America Exhibition, Nelson Gallery of Art, Kansas City, 1965

First Prize in Experimental Work, Scottsdale National Exhibition, 1966

Grand Prize, Biennial Exhibition of American Indian Arts and Crafts, Center for Arts of Indian America, 1967

Special Award, Polymer Painting, Scottsdale National Indian Exhibition, 1968

Grand Prize, Scottsdale National Indian Exhibition, 1969

Jurors Award, Museum of New Mexico, 1970, 1971, 1972

Selected Exhibitions

Selected Group Shows

Oakland Art Museum, Northern California Painters' Annual, 1961
Denver Art Museum, The Western Annual, 1961, 1971, 1973
California Palace of the Legion of Honor, San Francisco, Third Winter Invitational Exhibition, 1961–1962
Houston Museum of Fine Arts, The Southwest: Painting and Sculpture, 1962–1963
Dallas Museum of Fine Arts, Thirteenth Southwestern Exhibition of Prints and Drawings, 1963
William Rockhill Nelson Gallery of Art and Atkins Museum of Fine Arts, Kansas City, Fifteenth Mid-America
 Annual Exhibition, 1965
Edinburgh Art Festival, Scotland, North American Indian Art, 1967
Berlin Festival, Germany, North American Indian Art, 1967
Biblioteca Nacional, Santiago, Chile, North American Indian Art, 1968
Museo de Bellas Artes, Buenos Aires, North American Indian Art, 1968
The Marion Koogler McNay Art Institute, San Antonio, Masterpieces from the Museum of New Mexico, 1970
Utah Museum of Fine Arts, University of Utah, Salt Lake City, Twentieth Century American Drawings from the
 Collection of Edward Jacobson, 1972
The Brooklyn Museum, Eighteenth National Print Exhibition, 1972–1973
Museo la Tertulia, Cali, Colombia, Second Biennial of Graphic Art of the Americas, 1973
Linden-Museum, Stuttgart, Germany, Indianische Malerei in Nordamerika 1830–1970, 1973–1974
Anchorage Fine Arts Museum, Alaska, Second National Print Invitational, 1974
The Brooklyn Museum, Curator's Choice, 1975

One-Man Shows

Library Gallery, Sacramento City College, April 16–May 23, 1958.
Artists' Cooperative Gallery, Sacramento. February 20–March 12, 1959. Announcement.
E. B. Crocker Art Gallery, Sacramento. August 30–October 4, 1959. Checklist.
University of Arizona Museum of Art, Tucson. April 19–25, 1964.
College of Santa Fe. September 17–30, 1967. Announcement.
Roswell Art Center and Museum, Roswell, New Mexico. December 8, 1968–January 9, 1969. Checklist.
Esther Bear Gallery, Santa Barbara. January 24–February 15, 1971. Postcard.
Heard Museum, Phoenix. March 6–31, 1971. Brochure and checklist.
The Jamison Galleries, Santa Fe. Summer, 1971–1975. Catalog.
Tally Richards Gallery of Contemporary Art, Taos. Summer, 1971, 1973, 1975. Catalog.
National Collection of Fine Arts, Smithsonian Institution, Washington, D.C. "Two American Painters," April 7–May
 20, 1972. Catalog, poster, announcement. Exhibition traveled for a year to Bucharest, Belgrade, London,
 Berlin, and Ankara.
St. John's College, Santa Fe. "Scholder Collects Scholder," April 9–May 7, 1972. Catalog.
Cordier & Ekstrom, New York. October 14–November 18, 1972. Catalog.
Cedar Rapids Art Center, December 7, 1972–January 7, 1973. Catalog.
Sheldon Gallery, University of Nebraska, Lincoln. January 22–February 18, 1973. Catalog.
Albrecht Gallery, St. Joseph, Missouri. March 5–April 1, 1973. Catalog.
Hayden Gallery, Massachusetts Institute of Technology, Cambridge. April 13–May 5, 1973. Catalog, poster.
Charles M. Russell Gallery, Great Falls, Montana. April 17–May 6, 1973. Catalog.
Yellowstone Art Center, Billings, Montana. May 29–June 30, 1973.
Museum of New Mexico, Santa Fe (two-man show), September 16–October 28, 1973. Poster.
Jaffe-Friede Gallery, Dartmouth College, Hanover, New Hampshire. September 28–October 21, 1973. Catalog,
 poster.
Jaffe-Friede Gallery, Dartmouth College, Hanover, New Hampshire, December 3–4, 1973, "The Dartmouth
 Portraits." Poster.
Elaine Horwitch Gallery, Scottsdale, Arizona. March 3–22, 1974; March 2–22, 1975. Catalog, poster, postcard.
Brooks Memorial Art Gallery, Memphis, Tennessee. March 29–April 28, 1974. Catalog.
Aspen Gallery of Art, Colorado. June 14–July 5, 1974. Poster.

Art Gallery, University of North Dakota, Grand Forks. September 3–28, 1974. Postcard.
Cordier & Ekstrom, New York. January 8–November 9, 1974. Catalog.
Maxwell Galleries, San Francisco. September 10–28, 1974. Catalog.
Gallery Moos Ltd., Toronto. October 5–23, 1974. Catalog.
University of Texas, El Paso. October 30–November 30, 1974. Poster, checklist.
Brigham Young University, Provo, Utah. November 1–December 1, 1974. Checklist, poster.
Summit Art Center, Summit, New Jersey. March 2–30, 1975. Catalog.
Museum of Modern Art, Skopje, Yugoslavia, 1972.
American Embassy, Bucharest, 1972.
Amerika Haus, Berlin, 1972.
Basel Art 5, Switzerland, 1974.

Public Collections

Heard Museum, Phoenix, Arizona
Phoenix Art Museum
Scottsdale Fine Arts Center, Scottsdale, Arizona
Art Collections, Arizona State University, Tempe
University Art Museum, Berkeley, California
San Diego Fine Arts Gallery
De Saisset Art Gallery, University of California, Santa Clara
Denver Art Museum
Bureau of Indian Affairs, Washington, D.C.
Hirshhorn Museum, Smithsonian Institution, Washington, D.C.
National Collection of Fine Arts, Smithsonian Institution, Washington, D.C.
United States Indian Arts and Crafts Board, Washington, D.C.
Chicago Art Institute
Museum of Fine Arts, Boston, Massachusetts
Hallmark Card Company, Kansas City, Missouri
University of New Mexico Art Museum, Albuquerque
Summit Art Center, Summit, New Jersey
Museum of New Mexico, Santa Fe
Brooklyn Museum
Museum of Modern Art, New York City
Oklahoma Art Center, Oklahoma City
Portland Art Museum, Portland, Oregon
Philadelphia Museum of Art
Brooks Memorial Art Gallery, Memphis, Tennessee
Dallas Museum of Fine Arts
El Paso Museum of Fine Art
Houston Museum of Fine Arts
Brigham Young University, Provo, Utah
University of Utah Fine Arts Museum, Salt Lake City

Selected Bibliography

Books

Baumann, Peter, and Helmut Uhlig. *Kein Platz für wilde Menschen.* Vienna–Munich–Zurich: Verlag Fritz
 Molden, 1974. Paintings reproduced in color: "American Indian" and "The Bead Maker."
Brody J. J. *Indian Painters and White Patrons.* University of New Mexico Press, 1970. Dust jacket and text
 feature color reproduction of "Screaming Indian."
Dictionary of International Biography, London: 1968–1971.
Gilbert, Dorothy B., ed. *Who's Who in American Art.* New York: R. R. Bowker Co., 1962–1975.
Gridley, Marion E. *Indians of Today.* 4th ed. Chicago: Indian Council Fire Press, 1971.
Harold, Margaret. *Prize Winning Paintings.* Ford Lauderdale, Florida: Allied Publishing Co., 1964.
Icolari, Daniel, ed. *Encyclopedia of the American Indian,* 2nd ed. Vol. II. New York: Todd Publications, 1974.
Indian Voices: The First Convocation of American Indian Scholars at Princeton. San Francisco: The Indian
 Historical Press, 1970.
International Directory of Arts. Berlin: Deutsche Zentraldruckerei, 1968–1971.
Klein, Bernard, and Daniel Icolari, eds. *Encyclopedia of the American Indian.* New York: B. Klein and Co.,
 1967.
Mondale, Joan Adams. *Politics in Art.* Minneapolis: Lerner Publications Co., 1972. Painting reproduced:
 "American Indian."
Monthan, Doris, ed. *Scholder/Indians.* Introduction by Adelyn D. Breeskin; commentary by Rudy H. Turk.
 Flagstaff, Ariz.: Northland Press, 1972.
———— and Guy Monthan. *Art and Indian Individualists.* Flagstaff, Ariz.: Northland Press, 1975. Paintings
 reproduced: "Indian with Sunglasses" (frontispiece), "Indian with Top Hat and Umbrella," "Massacre in
 America: Wounded Knee," "Fighting Buffalo," "Dartmouth Portrait No. 2." Lithograph: "Laughing Artist."
Price, Vincent. *The Vincent Price Treasury of Modern Art.* Waukesha, Wis.: Country Beautiful Corp., 1972.
 Painting reproduced: "American Indian."
Snodgrass, Jeanne O. *American Indian Painters.* New York: Museum of the American Indian, 1968.
Who's Who in the West. Chicago: Marquis Who's Who, Inc., 1965–1975.
The World of the American Indian. Washington, D.C.: National Geographic Society, 1974. Painting reproduced
 in color: "Super Indian No. 2."

Journals and Magazines

Art News. "Artists in the Art News: Winners of the John Hay Whitney Opportunity Fellowship." September 1962,
 p. 9.
Arts Magazine. "Fritz Scholder" (review). March 1974, p. 60.
————. "On the Work of a Contemporary American Indian Painter." *Leonardo* (Great Britain), vol. 6, 1973.
 Painting reproduced in color: "Screaming Artist." Paintings reproduced in black and white: "Insane
 Warrior," "Sioux and Horse," "Arapaho Feather Fan." Lithograph: "Screaming Artist."
Boulay, Peter C. "Indians Forever, Part One, Problems, Problems." Drawing from poster "Indians Forever" on
 cover. *Arizona Teacher,* October–November 1969, pp. 14–17.
Coates, Robert M. "Indian Affairs, New Style." *New Yorker,* 17 June 1969.
Constable, Rosalind. "The Vanishing Indian." *Art in America,* January–February 1970.
Cortright, Barbara. "Prophet with Honor." Paintings reproduced: "Indian Vision," and "Indian and Fire." *Phoenix
 Magazine,* March 1974, pp. 60–61, 103.
Ewing, Robert A. "The New Indian Art." Paintings reproduced: "Moccasin Pattern," "Insane Indian," and
 "Indian and Rhinoceros." *El Palacio,* Spring 1969, pp. 33–38.
Halasz, Piri. "Fritz Scholder's Indian Paradoxes." Painting reproduced: Dartmouth Portrait No. 1. *Art News,*
 October 1974, pp. 90–94.
Kent, Rosemary. "Honest Indian." *Gentlemen's Quarterly.* May 1975, p. 11.
La Riviere, Anne L. "New Art by the Oldest Americans." Paintings reproduced in color: "One Quarter Luiseño
 No. 2," "American Indian," "Indian No. 16," "Indian Actor," "Indian with Beer Can." *Westways,* May 1973, pp.
 18–23.

Locke, Raymond Friday. "Fritz Scholder's Real Indians." Paintings reproduced in color: "Indian Power," "Adobe Church," Dartmouth Portraits Nos. 16, 23, 24, "Hollywood Indian No. 5," "Back from the Indian School," "Indian, Dog and Tepee." Paintings reproduced in black and white: "Indian Revenge," "Indian on Galloping Horse," "Indian, Dog and Friend," "Standing Indian." *Mankind Magazine,* June 1974, pp. 24–29, 41–43.

Meigs, John. "Experience in Excellence: An Artist's View." Painting reproduced in color: "Super Pueblo No. 2." *New Mexico Magazine,* May–June 1970, p. 25.

Motive. Paintings reproduced: "American Indian" on cover and "Waiting Indian No. 4" on back cover. April–May 1971.

New, Lloyd. "A New Vitality Rekindles Proud Fires of the Past." "Indian Arts and Crafts: America's Heritage, How It's Changing." Paintings reproduced: "Indian with Strawberry Soda Pop" and "American Indian." *House Beautiful,* June 1971, p. 134–135.

Oxendine, Lloyd E. "23 Contemporary Indian Artists." *Art In America.* Painting reproduced in color: "Super Indian No. 2." July–August 1972, pp. 58–69.

Richards, Tally. "Fritz Scholder at 35." Painting reproduced: "Back from the Indian School." Lithograph: "Indian with Flag No. 2." *Southwest Art Gallery Magazine,* May 1973, pp. 40–41.

———. "Scholder, Dartmouth: Renewed Commitments." Paintings reproduced: Dartmouth Portraits Nos. 10, 9, 13, 12, 17, 16, 14, "Indian After Remington," "Indian with Heart." *Southwest Art Gallery Magazine,* March 1974, pp. 40–45.

Self, Winke. "Cutting Through Indian Romanticism." Painting reproduced: "Screaming Indian No. 2." *San Diego Magazine,* July 1972, pp. 40–42.

Smoke Signals. "Grand Prize Winner, 1967 Biennial Exhibition of American Indian Art, Washington, D.C." Painting featured: "Indian No. 16." Spring 1968, p. 42.

South Dakota Review. "Indian Art: Fritz Scholder, Self-Interview: The Emergence of the New Indian Art as Seen by Fritz Scholder. Indian Artist/Non-Indian Artist." Summer 1971, pp. 75–86.

Southwestern Art. "Fritz Scholder: New Indian Oils." Paintings reproduced: "New Mexico No. 42," "Indian with a Dog," and "Kiva at San Ildefonso and Dog." Vol. II, No. 4, 1970, pp. 56–57.

Taylor, Joshua C. "Fritz Scholder." Painting reproduced in color: Dartmouth Portrait No. 2. Paintings reproduced in black and white: Dartmouth Portraits Nos. 6, 3. *Arizona Highways,* January 1974, pp. 4–6.

Turk, Rudy. "Indian Present." Paintings reproduced in color: "Four Indian Riders," "Indian Actor," "Super Indian No. 2," "Indian Forever." Lithograph: "Indian at the Bar." *Intellectual Digest,* October 1972, pp. 47–50.

Waugh, Lynne. "Will Success Spoil Fritz Scholder?" Paintings reproduced in color: "Kiva at San Ildefonso and Dog," "Blackfeet Tepee," "Indian Called Horse," "Indian at Gallup," "Indian on Horseback," and "American Indian." *New Mexico Magazine,* May–June 1971, pp. 36–40.

United States Newspapers

Albuquerque Journal. "Fritz Scholder Given Top Prize in Indian Show." November 1967.
———. "Santa Fean's Indian Pop Art Praised in the East." 19 April 1970.
Arizona Daily Star. "U.A. Artist Gets $1,963 First Prize." Tucson, 3 February 1963.
Arizona Republic. "Scholder Has a Spoofing Way in Canvases, Sculpture." 14 March 1971.
Artnes, Alan G. "Mirroring a Twin Set of Differences." *Chicago Tribune,* 25 November 1973.
Belshe, Mirella. "Beyond the Reservation." *The Sunday Star-Bulletin,* Honolulu, 22 September 1974.
Bond, Rowland. "Silence Greets Indian Art: Painting Controversial." *Spokane Chronicale,* 28 October 1967.
Breitner, Bina. "Indian Artist Scholder's Works Shown at Heard." *Arizona Republic,* 8 March 1971.
Brown, Doris. "Fritz Is a Trail-Blazer." *Sunday Home News,* New Brunswick, N.J., 29 March 1970.
Canady, John. "Art." *The New York Times,* 12 January 1974.
Celebrity Bulletin. "Weekend Celebrity: Fritz Scholder." New York City: 27 February 1970.
Cortright, Barbara. "Fritz Scholder: Compassion, Irony, Indignation Combined." *Artweek,* 27 March 1975.
Durbin, Louise. "Cocktail Parties and a Cowskin in the Bathtub." *The Washington Post,* 22 March 1970.
Feighan, Fleur. "Scholder Show Now at Heard." *Scottsdale Progress,* 19 March 1971.
Frankenstein, Alfred. "Levitation, Huge Heads and Indians." *San Francisco Chronicle,* 28 September 1974.

Glueck, Grace. "Three Artists, Three Different Terrains." *The New York Times,* 3 February 1974.

Halasz, Piri. "Art: Show in Summit Is a Tribute to American Indian." *The New York Times,* 16 March 1975.

Jennings, Jan. "Scholder: His Works Are Bold." *San Diego Evening Tribune,* 19 May 1972.

Kansas City Star. "Artist Stays Close to Indian Tradition." 19 May 1965.

Kelley, Mary Lou. "Contemporary Awareness in Scholder's Indian Art." *The Christian Science Monitor,* 30 April 1973.

Lague, Louise. "Put-ons of Indians by Indians." *The Washington Daily News,* 7 April 1972.

La Riviere, Anne. "Newest Art by the Oldest Indians." *Los Angeles Times,* 7 January 1972.

Micuda, Jean. "Scholder, Indian of the Moment." *Arizona Living,* 11 February 1972.

Miller, Marlan. "Scholder Book Takes Probing Look at Art." *The Phoenix Gazette,* 8 July 1972.

New Mexican. "Fritz Scholder Named Winner of $500 Hallmark Award." Santa Fe, May 1965.

Newton, Jim. "Despite Image Scholder Fan of Indians." *The Phoenix Gazette,* 12 February 1972.

Nordell, Roderick. "Two American Painters in Capital." *The Christian Science Monitor,* 15 May 1972.

Northrop, Guy. "Scholder Retrospective Show Is a Prize for Brooks." *The Commercial Appeal,* Memphis, 7 April 1974.

Oglesby, John C. "Fritz Scholder Show Draws Instant Response." *Sacramento Bee,* 8 March 1959.

Patterson, Ann. "Scholder: Protest behind the Brush." *Scottsdale Progress,* 11 February 1972.

Raymer, Patricia L. "Painting the RealIndian." *The Washington Post,* 9 January 1973.

Scholastic News Explorer. "Pop Indian." Dayton, Ohio, 9 November 1970.

Secrest, Meryle. "A 'Pop' Look at Indian Culture." *The Washington Post,* 9 April 1972.

Stafford, Thomas F. "State Unkind to Art Winner." *The Charleston Gazette,* West Virginia, 30 January 1963.

Taos News. "Art Center Buys Scholder's Works." 15 September 1971.

Trimble, Walter. "Fritz Scholder and New Indian Art in America." *New Mexico Cultural News,* August 1970.

Tulsa Daily World. "New Indian ArtPotential Hailed: Fritz Scholder." 16 June 1968.

Waugh, John C. "Pop Indian Emerges from a New Renaissance." *The Christian Science Monitor,* 11 September 1970.

————. "Decade of the Indian." *The Christian Science Monitor,* 5 January 1971.

Waugh, Lynne. "Fritz Scholder Has Changed American Indian Art." *Albuquerque Journal,* 14 February 1971.

————. "The Artistry of the Indian." Paintings reproduced in color: "Navajo and Horse" (Cover), "Indian and Horse," "American Indian," "Hopi Maiden." *Chicago Tribune Magazine,* 25 February 1973, pp. 18–19.

Wilson, Maggie. "Young Indians Dig Fritz Scholder." *The Phoenix Gazette,* 4 March 1971.

————. "Indian Artist Blazes Way into Fine Art." *Arizona Republic,* 13 February 1972.

Exhibition Catalogues (Chronologically Arranged)

San Francisco. California Palace of the Legion of Honor. *Third Winter Invitational Exhibition.* December 23, 1961–January 21, 1962. Introduction by Howard Ross Smith.

Houston. The Museum of Fine Arts. *The Southwest: Painting and Sculpture.* December 7, 1962–January 20, 1963. Foreword by James Johnson Sweeney.

Huntington, West Virginia. Huntington Galleries. *Centennial Exhibition of Painting and Sculpture.* January 27–February 24, 1963. Introduction by William Wallace Brown, Governor. Juror: James Johnson Sweeney.

Kansas City. William Rockhill Nelson Gallery of Art and Atkins Museum of Fine Arts. *15th Mid-America Annual Exhibition.* May 14–June 13, 1965.

Colorado Springs. Colorado Spring Fine Arts Center. *21st Artists West of the Mississippi.* July 6–September 6, 1967. Introduction by Fred S. Bartlett, Director.

Washington, D.C. Center for Arts of Indian America. *1967 Biennial Exhibition of American Indian Arts.* November 6–December 15, 1967.

Washington, D.C. Center for Arts of Indian America. *Three from Santa Fe.* May 6–June 28, 1968. Introduction by Vincent Price.

San Antonio. The Marion Koogler McNay Art Institute. *Masterpieces from the Museum of New Mexico.* February 8–March 8, 1970. Introduction by John Palmer Leeper, Director.

Denver. The Denver Art Museum. *The 73rd Western Annual.* October 3–November 21, 1971. Introduction by Lewis Wingfield Story.

El Paso. Union Galleries, University of Texas. *A Blending of Cultures—A Blending of Time.* October 24–November 5, 1971.

Salt Lake City. University of Utah Museum of Fine Arts. *Twentieth Century American Drawings from the Collection of Edward Jacobson.* Introduction by Vincent Price. Text by E. F. Sanguinetti.

Washington, D.C. National Collection of Fine Arts, Smithsonian Institution. *Two American Painters.* April 7–May 29, 1972. Foreword by Joshua C. Taylor; "New Indian Art" by Robert A. Ewing; Biographical Notes by Adelyn D. Breeskin.

Roswell, New Mexico. Roswell Art Museum. *Fall Invitational.* September 17–October 11, 1972.

Brooklyn. The Brooklyn Museum. *Eighteenth National Print Exhibition.* November 22, 1972–February 4, 1973. Introduction by Jo Miller.

Denver. The Denver Art Museum. *The 74th Western Annual.* January 27–March 4, 1973. Introduction by Lewis Wingfield Story.

Cambridge. Massachusetts Institute of Technology. Hayden Gallery. *Scholder-Indians.* April 13–May 5, 1973. Quotes by Fritz Scholder; Text by Joshua C. Taylor.

Hanover, New Hampshire. Jaffe-Friede Gallery, Dartmouth College. *Fritz Scholder.* September 28–October 21, 1973. Introduction by Matthew Wysocki and Churchill P. Lathrop, Director.

Stuttgart. Linden-Museum. *Indianische Malerei in Nordamerika 1830–1970.* November 1, 1973–February 10, 1974. Introduction by Friedrich Kussmaul.

Memphis. Brooks Memorial Art Gallery. *Fritz Scholder Retrospective.* March 29–April 28, 1974. Introduction by Joseph S. Czestochowski.

Films

1972 *Three Indian Artists,* Produced by KAET Television, Phoenix, Arizona. 30 min.

1975 *Scholder the Magician,* Produced by Toti Bertrand, Spain. 15 min.

1976 *Fritz Scholder,* Produced by Public Broadcasting System; filmed by KAET Television, Phoenix, Arizona. 30 min.

Catalogue of the Lithographs

All works are lithographs, listed in chronological order. Dimensions are in inches and centimeters (in parentheses), height preceding width. Sheet sizes are given. Except as indicated, the lithographs were printed at Tamarind Institute; the Tamarind number appears in brackets. This number also appears in pencil on the reverse side of each impression. The following abbreviations are used in describing the editions; no other impressions exist, and all stones and plates have been effaced.

BAT	*Bon à tirer* impression		SP	Separation proof
PrP	Printer's proof		CSP	Color separation proof
TP	Trial proof		PgP	Progressive proof
CTP	Color trial proof		CP	Cancellation proof
AP	Artist's proof			At Editions Press only: catalogue entries 46–49:
PP	Presentation proof		PrP II	Printer's Proof II
T	Tamarind impression		EPAP	Editions Press artist proof
R	Roman numbered edition		EPI	Editions Press impression

1970

1. WAITING INDIAN (Indians Forever Suite)
 December 1970 [70-183], one color
 30 × 22 (76.2 × 55.9), white Arches
 Edition: 75 plus BAT, 4TP, CTP, 6AP, 2T, 5R,
 2PP, CP
 Printed by Julio Juristo
 Page 42

2. INDIAN WITH FEATHER (Indians Forever Suite)
 December 1970 [70-184], one color
 30 × 22 (76.2 × 55.9), German etching paper
 Edition: 75 plus BAT, 2TP, 2CTP, 6AP, 2T, 5R,
 2PP, CP
 Printed by Tracy White
 Page 43

3. INDIAN AT THE CIRCUS (Indians Forever Suite)
 December 1970 [70-185], five color
 30 × 22 (76.2 × 55.9), German etching paper
 Edition: 75 plus BAT, 4TP, CTP, 6AP, 2T, 5R,
 2PP, CP
 Printed by Tracy White and Wayne Kimball
 Page 14

4. INDIAN RUG
 December 1970 [70-620]
 30 × 22 (76.2 × 55.9)
 One unsigned, unchopped impression retained
 by the artist
 Printed by Wayne Simpkins
 Page 44

5. INDIAN WITH PIGEON (Indians Forever Suite)
 December 1970 [70-188], two color
 22 × 30 (55.9 × 76.2), buff Arches
 Edition: 75 plus BAT, 5TP, 3CTP, 6AP, 2T, 5R,
 2PP, CP
 Printed by Tracy White
 Page 45

6. SQUASH BLOSSOM INDIAN NECKLACE
 December 1970 [71-612], two color
 30 × 22 (76.2 × 55.9), Fasson self-adhesive foil
 on rag paper
 Proofs: CTP, RI, CP
 Printed by Tamarind Printer Fellows
 Page 46

1971

7. KACHINA MASK
 January 1971 [71-639], one color
 30 × 22 (76.2 × 55.9), buff Arches
 One unsigned, unchopped impression retained
 by the artist
 Printed by Tracy White
 Page 48

8. KACHINA DANCERS (Indians Forever Suite)
 January 1971 [71-105], three color
 22 × 30 (55.9 × 76.2), buff Arches
 Edition: 75 plus BAT, 7TP, 4CTP, 6AP, 2T, 5R,
 2PP, CP
 Printed by Julio Juristo
 Page 11

9. BUFFALO DANCER (Indians Forever Suite)
 January 1971 [71-107], one color
 30 × 22 (76.2 × 55.9), buff Arches
 Edition: 75 plus BAT, 5TP, 6AP, 2T, 5R, 2PP, CP
 Printed by Wayne Kimball
 Page 49

10. INDIAN NOTE BOOK PAGE
 January 1971 [71-613], one color
 20 × 27½ (50.8 × 69.8), buff Arches, white
 Arches, German etching paper
 Proofs: 7TP, 7 lettered proofs, CP
 Printed by Tamarind Printer Fellows
 Page 50

11. INDIAN AT THE BAR (Indians Forever Suite)
February 1971 [71-117], four color
30 × 22 (76.2 × 55.9), buff Arches
Edition: 75 plus BAT, 5TP, 6AP, 2T, 5R,
2PP, CP
Printed by Wayne Simpkins
Page 15

12. SELF-PORTRAIT
February 1971 [71-614], two color
30 × 22 (76.2 × 55.9), buff Arches, Fasson
self-adhesive foil on rag paper
Proofs: TP, 10CTP, RI, CP
Printed by Wayne Kimball
Page 51

13. INDIAN CHIEF
February 1971 [71-602], one color
10¾ × 15 (27.3 × 38.1); Magnani Italia,
Crisbrook Waterleaf
Proofs: 3 lettered proofs
Printed by Wayne Simpkins
Page 56

14. INDIAN AND HORSE
February 1971 [71-644]
30 × 22 (76.2 × 55.9), buff Arches
One unsigned, unchopped impression retained
by the artist
Printed by Tamarind Printer Fellows
Not illustrated

15. INDIAN AND HORSE NO. 2
February 1971 [71-615], two color
30 × 22 (76.2 × 55.9), buff Arches, white
Arches, German etching paper
Proofs: TP, 3CTP, 2RI, 2CP
Printed by Tamarind Printer Fellows
Page 55

16. WILD INDIAN
February 1971 [71-616], three color
30 × 22 (76.2 × 55.9), buff Arches
Proofs: TP, 11CTP, RI, 3CP
Printed by John Butke
Page 54

17. POSTCARD
February 1971 [71-617a], two color
22 × 30 (55.9 × 76.2), buff Arches
Proofs: 11CTP, RI
Printed by Wayne Simpkins
Page 52

18. POSTCARD NO. 2
February 1971 [71-617b], two color
22 × 30 (55.9 × 76.2), buff Arches
Proofs: 2CTP, 2RI, CP
Printed by Wayne Simpkins
Page 53

19. INDIAN DANCER
March 1971 [71-618], one color
30 × 22 (76.2 × 55.9), buff Arches, German
etching paper
Proofs: 2TP, 4CTP, RI, CP
Printed by Wayne Kimball
Page 57

20. INDIANS WITH UMBRELLAS (Indians Forever
Suite)
March 1971 [71-152], four color
22 × 30 (55.9 × 76.2), buff Arches
Edition: 75 plus BAT, 4TP, 6CTP, 6AP, 2T, 5R,
2PP, CP
Printed by John Butke
Page 10

21. ABIQUIU AFTERNOON
March 1971 [71-141], one color
25½ × 20 (64.8 × 50.8), German etching paper
Edition: 50 plus BAT, 5TP, CTP, 5AP, 2T, 5R, CP
Printed by John Sommers
Page 58

22. INDIAN WITH WOMAN
August 1971 [71-195], three color
30 × 22 (76.2 × 55.9), buff Arches
Edition: 50 plus BAT, 2TP, 12CTP, 5AP, 2T, 5R,
CP
Printed by Wayne Kimball
Page 59

23. DARK INDIAN
August 1971 [71-619], one color
30 × 22 (76.2 × 55.9), white Arches
Proofs: TP, RI
Printed by Ron Kraver
Page 60

24. INDIAN ON HORSE
August 1971 [71-631], two color
22 × 30 (55.9 × 76.2), buff Arches, white
Arches, black Arches, German etching paper
Proofs: TP, 10CTP, RI
Printed by Wayne Kimball
Page 61

25. WOMAN IN ORANGE CHAIR
August 1971 [71-207], two color
22 × 30 (55.9 × 76.2), buff Arches
Edition: 50 plus BAT, 3TP, 3CTP, 5AP, 2T, 5R,
CP
Printed by Wayne Simpkins
Page 62

26. INDIAN TARGET
August 1971 [71-208], one color
11¼ × 7 (28.6 × 17.8), buff Arches
Edition: 50 plus BAT, 3TP, 3CTP, 5AP, 2T, 5R,
CP
Printed by John Butke
Page 63

27. CROW INDIAN
August 1971 [71-209], one color
11¼ × 7 (28.6 × 17.8), buff Arches
Edition: 50 plus 5AP, 2T, 5R
Printed by John Butke
Page 64

28. TIRED INDIAN
August 1971 [71-210], one color
11¼ × 7 (28.6 × 17.8), buff Arches
Edition: 50 plus 5AP, 2T, 5R
Printed by John Butke
Page 65

155

29. INDIAN PORTRAIT
August 1971 [71-211], one color
11 × 9 (27.9 × 22.9), buff Arches
Edition: 50 plus 5AP, 2T, 5R
Printed by John Butke
Page 66

30. INDIAN AT THE WINDOW
August 1971 [71-212], one color
11¼ × 7 (28.6 × 17.8), buff Arches
Edition: 50 plus 5AP, 2T, 5R
Printed by John Butke
Page 67

31. INDIAN WITH PIPE BAG
August 1971 [71-213], one color
11 × 8¼ (27.9 × 21), buff Arches
Edition: 50 plus 5AP, 2T, 5R
Printed by John Butke
Page 68

32. CAT WOMAN
August 1971 [71-214], one color
10½ × 7 (26.7 × 17.8), buff Arches
Edition: 50 plus 5AP, 2T, 5R
Printed by John Butke
Page 69

33. SQUATTING WOMAN
August 1971 [71-215], one color
12 × 7 (30.5 × 17.8), buff Arches
Edition: 50 plus 5AP, 2T, 5R
Printed by John Butke
Page 70

34. WOMAN WITH SNAKES
August 1971 [71-216], three color
30 × 22 (76.2 × 55.9), buff Arches
Edition: 50 plus BAT, TP, 6CTP, 5AP, 2T, 5R, PP,
CP
Printed by Ron Kraver and John Butke
Page 71

35. SELF-PORTRAIT, October 7, 1971
October 1971 [71-642], one color
30 × 22 (76.2 × 55.9), buff Arches, white
Arches, Nacre, Fasson self-adhesive foil
mounted on Rives BFK
Proofs: 5TP, 4CTP, RI
Printed by Wayne Kimball
Page 72

36. SCREAMING ARTIST
November 1971 [71-223], one color
30 × 22 (76.2 × 55.9), buff Arches
Edition: 50 plus BAT, 2TP, 5AP, 2T, 5R, CP
Printed by Wayne Kimball
Page 73

37. INDIAN WITH BLANKET NO. 1
November 1971 [71-640], one color
11 × 7 (27.9 × 17.8), buff Arches
Edition: 50 plus BAT, TP, 5AP, 2T, CP
Printed by Wayne Kimball
Page 74

38. INDIAN WITH BLANKET NO. 2
November 1971 [71-641], one color
11 × 7 (27.9 × 17.8), buff Arches
Edition: 50 plus BAT, TP, 5AP, 2T, CP
Printed by Wayne Kimball
Page 75

156

39. PUEBLO DOG
November 1971 [71-647], one color
15 × 11½ (38.1 × 29.2), white Arches
Edition: 50 plus BAT, 5TP, 5AP, 2T, CP
Printed by John Sommers
Page 76

1972

40. AMERICAN INDIAN NO. 4
May 1972 [72-204], two color
30 × 22 (76.2 × 55.9), uncalendered Rives BFK
Edition: 100 plus BAT, 3TP, 10AP, 2T, 5R, CP
Printed by Harry Westlund
Page 82

41. GALLOPING INDIAN NO. 2
May 1972 [72-205], three color
22 × 30 (55.9 × 76.2), uncalendered Rives BFK
Edition: 50 plus BAT, 5TP, 2CTP, 5AP, 2T, 5R,
CP
Printed by Harry Westlund
Page 83

42. ROMONA
May 1972 [72-206], two color
20 × 18 (50.8 × 45.7), buff Arches
Edition: 50 plus BAT, 2TP, 2CTP, 5AP, 2T, 5R,
CP
Printed by Harry Westlund
Page 78

43. INDIAN IN SPOTLIGHT
July 1972 [72-207], one color
22 × 17¼ (55.9 × 43.8), buff Arches
Edition: 20 plus BAT, 2TP, 2CTP, AP, 2T, 5R, CP
Printed by Ben Q. Adams
Page 79

44. INDIAN WITH RED BUTTON
September 1972 [72-656a], two color
22 × 30 (55.9 × 76.2), buff Arches
Edition: 100 plus BAT, 5TP, 10AP, 2T
Printed by Harry Westlund
Page 80

45. INDIAN WITH BUTTON
September 1972 [72-656b], one color
22 × 30 (55.9 × 76.2), Rives BFK
Edition: 30 plus BAT, TP, 3AP, 2T, CP
Printed by Harry Westlund
Page 81

1973

46. INDIAN WITH CAT
February 1973 [Editions Press 286], four color
30 × 22 (76.2 × 55.9), buff Arches
Edition: 100 plus BAT, 2PrP II, TP, EPAP, 15AP,
4PP, 11EPI, 2SP, CP
Printed by Voorhees Mount
Page 86

66. BUCKSKIN INDIAN (Third State)
May 1974 [74-187], one color
30 × 22 (76.2 × 55.9), buff Arches
Edition: 20 plus BAT, TP, 5AP, 2T, 7R
Printed by Harry Westlund
Not illustrated

67. LAUGHING ARTIST (First State)
May 1974 [74-638], four color
30 × 22 (76.2 × 55.9), white Arches
Edition: 65 plus BAT, TP, 2CTP, 2T
Printed by Harry Westlund
Page 110

68. LAUGHING ARTIST (Second State)
May 1974 [74-638a], four color
30 × 22 (76.2 × 55.9), Rives BFK
Edition: 35 plus BAT, 2CTP, 2T
Printed by Harry Westlund
Page 111

69. COWBOY INDIAN (First State)
May 1974 [74-636], two color
24 × 17 (58.4 × 43.2), Rives BFK
Edition: 100 plus BAT, TP, 8CTP, 8AP, 2T
Printed by Ben Q. Adams
Page 108

70. COWBOY INDIAN (Second State)
May 1974 [74-178], one color
24 × 17 (58.4 × 43.2), white Arches
Edition: 20 plus BAT, 5TP, 2AP, 2T, 7R
Printed by Ben Q. Adams
Page 109

71. HOPI DANCERS (First State)
May 1974 [74-637a], two color
22 × 30 (55.9 × 76.2), buff Arches
Edition: 75 plus BAT, 3TP, 8AP, 2T
Printed by Ben Q. Adams
Page 113

72. HOPI DANCERS (Second State)
May 1974 [74-637], one color
22 × 30 (55.9 × 76.2), buff Arches
Edition: 75 plus BAT, 4TP, 7AP, 2T
Printed by Ben Q. Adams
Page 112

73. APACHE NIGHT DANCER (First State)
May 1974 [74-634], three color
22 × 15 (55.9 × 38.1), buff Arches
Edition: 100 plus BAT, 3TP, 10AP, 2T
Printed by Stephen Britko
Page 114

74. APACHE NIGHT DANCER (Second State)
May 1974 [74-181], one color
22 × 15 (55.9 × 38.1), buff Arches
Edition: 20 plus BAT, 2TP, AP, 2T, 7R
Printed by Stephen Britko
Page 115

75. FEATHER FAN (First State)
May 1974 [74-639], one color
14 × 10 (35.6 × 25.4), buff Arches
Edition: 50 plus BAT, TP, 4AP, 2T
Printed by Ben Q. Adams
Page 118

76. FEATHER FAN (Second State)
May 1974 [74-639a], one color
14 × 10 (35.6 × 25.4), buff Arches
Edition: 50 plus BAT, 5AP, 2T
Printed by Ben Q. Adams
Page 119

77. NIGHT PUEBLO (First State)
May 1974 [74-640], one color
14 × 10 (35.6 × 25.4), buff Arches
Edition: 50 plus BAT, TP, 5AP, 2T
Printed by Ben Q. Adams
Page 122

78. NIGHT PUEBLO (Second State)
May 1974 [74-640a], one color
14 × 10 (35.6 × 25.4), buff Arches
Edition: 50 plus BAT, TP, 5AP, 2T
Printed by Ben Q. Adams
Page 123

79. TO SANTA FE FROM GALISTEO NO. 2 (First State)
May 1974 [74-641], one color
10 × 14 (25.4 × 35.6), buff Arches
Edition: 50 plus BAT, 2TP, 5AP, 2T
Printed by Ben Q. Adams
Page 130

80. TO SANTA FE FROM GALISTEO NO. 2 (Second State)
May 1974 [74-641a], one color
10 × 14 (25.4 × 35.6), buff Arches
Edition: 50 plus BAT, TP, 5AP, 2T
Printed by Ben Q. Adams
Page 131

81. HOPI POT (First State)
May 1974 [74-642], one color
10 × 14 (25.4 × 35.6), buff Arches
Edition: 50 plus BAT, TP, 5AP, 2T
Printed by Ben Q. Adams
Page 132

82. HOPI POT (Second State)
May 1974 [74-642a], one color
10 × 14 (25.4 × 35.6), buff Arches
Edition: 50 plus BAT, TP, 5AP, 2T
Printed by Ben Q. Adams
Page 133

83. BICENTENNIAL INDIAN
September 1974 [74-701], four color
22 × 30 (55.9 × 76.2), Rives BFK
Edition: 125 plus BAT, 4TP, 2CTP, 13AP, 2T, CP
Printed by Harry Westlund
Pages 120–121

84. NEW MEXICO (First State)
September 1974 [74-702], five color
30 × 22 (76.2 × 55.9), buff Arches
Edition: 120 plus BAT, 3TP, 5AP, 2T
Printed by Jim Reed
Page 116

85. NEW MEXICO (Second State)
September 1974 [74-246], one color
30 × 22 (76.2 × 55.9), buff Arches
Edition: 20 plus BAT, 2TP, 2AP, 2T, 7R
Printed by Jim Reed
Page 117